the art of
people photography

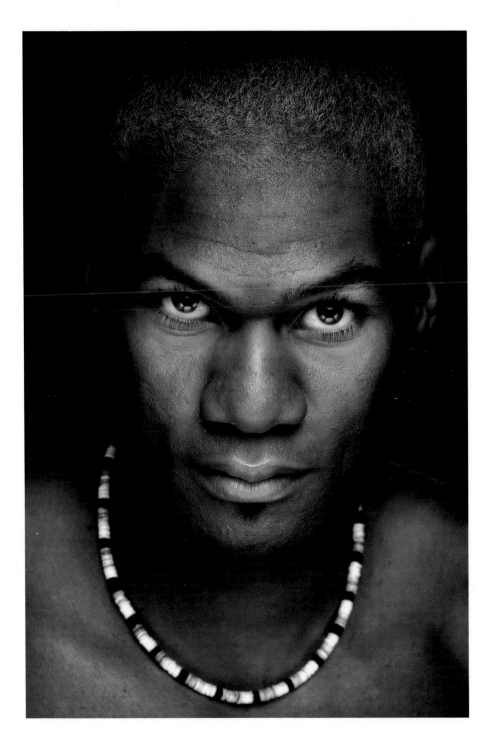

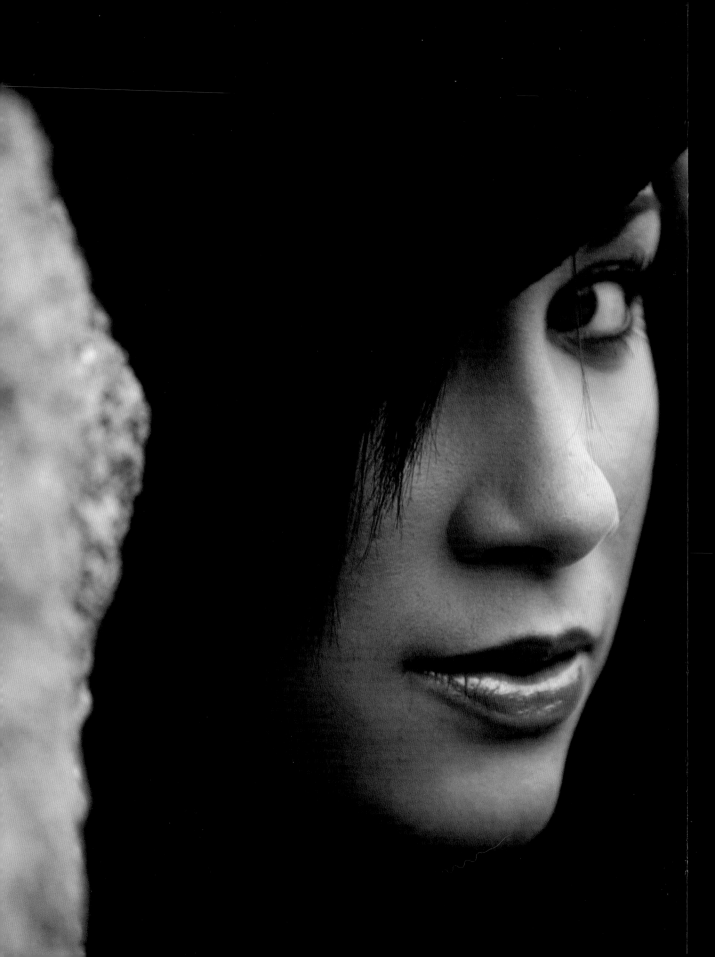

the art of
people
photography

Inspiring Techniques
for Creative Results

Bambi Cantrell
AND Skip Cohen

AMPHOTO BOOKS

An imprint of Watson–Guptill Publications
New York

PAGE 1: 70–200mm lens at 150mm, 1/125 sec. at f/9, ISO 100, Manual mode

PAGES 2–3: 28–70mm lens at 28mm, f/2.8 for 1/125 sec., ISO 100, Aperture Priority mode, Proofz Photoshop Action Infrared #1

PAGE 5: 28–70mm lens at 55mm, f/3.5 for 1/160 sec., ISO 100, Aperture Priority mode

PAGE 6: 28–70mm lens at 70mm, 1/60 sec. at f/5.6, ISO 100, Manual mode, Proofz Photoshop Action Infrared #1

PAGES 8–9: 70–200mm lens at 200mm, f/2.8 for 1/60 sec., ISO 100, Aperture Priority mode, Nik Color Infrared

PAGE 18: 70–200mm lens at 160mm, f/2.8 for 1/125 sec., ISO 100, Aperture Priority mode, Kevin Kubota Photoshop Action Cross-Processed

PAGE 36: 85mm lens, f/1.2 for 1/30 sec., ISO 100, Aperture Priority mode, Nik Black and White

PAGE 46: 70–200mm lens at 200mm, f/2.8 for 1/15 sec., ISO 100, Aperture Priority mode, Nik Midnight Blue

PAGE 68: 28–70mm lens at 70mm, f/3.2 for 1/200 sec., ISO 100, Aperture Priority mode

PAGE 94: 70–200mm lens at 200mm, f/2.8 for 1/15 sec., ISO 400, Aperture Priority mode, Proofz Photoshop Action Black and White, lighting: only modeling lamp from Profoto main light with a single reflector

PAGE 106: 70–200mm lens at 200mm, f/2.8 for 1/60 sec., ISO 100, Aperture Priority mode, Nik Midnight

PAGE 126: 70–200mm lens at 200mm, f/2.8 for 1/125 sec., ISO 100, Kevin Kubota Photoshop Action Sepia

PAGE 138: 70–200mm lens at 200mm, f/2.8 for 1/15 sec., ISO 100, Aperture Priority mode, Nik Midnight

PAGE 158: 70–200mm lens at 200mm, f/2.8 for 1/30 sec., ISO 400, Aperture Priority mode, Kevin Kubota Photoshop Action Cross-Processed

Editorial Director: Victoria Craven
Art Director: Julie Duquet
Designer: Areta Buk/Thumb Print
Senior Production Manager: Alyn Evans

First published in 2007 by Amphoto Books
an imprint of Watson-Guptill Publications
a division of VNU Business Media, Inc.
770 Broadway, New York, NY 10003
www.watsonguptill.com
www.amphotobooks.com

Illustrations copyright © 2007 Bambi Cantrell
Text copyright © 2007 Skip Cohen

Typeset in 11pt Adobe Caslon Regular

Library of Congress Cataloging-in-Publication Data
Cantrell, Bambi.
 The art of people photography : inspiring techniques for creative results / Bambi Cantrell and Skip Cohen.
 p. cm.
 Includes index.
 ISBN-13: 978-0-8174-5567-5 (pbk.)
 ISBN-10: 0-8174-5567-1 (pbk.)
 1. Portrait photography. I. Cohen, Skip. II. Title.

 TR575.C26 2007
 778.9'2—dc22

 2006026265

Printed in Thailand

1 2 3 4 5 6 7 8 9 / 15 14 13 12 11 10 09 08 07

acknowledgments

No book project like this is completed without significant help and inspiration from a long list of family, friends, and associates. We especially want to thank our families:

Steve, Cameron, and Alethea: I feel so lucky and blessed to have your never-ending support and love. —*Bambi*

To Deb, Adam, Lisa, Zachary, Luke, Jaime, and Dane: Where would I be without your help, patience, and support? Sure do love you guys! —*Skip*

To Yervant, Jerry Ghionis, Terry Deglau, Bob Rose, Michael Van Auken, Victoria Craven, Kayce Baker, Steve Sheanin, Bill Hurter, Dave Metz, Dan Steinhardt, Steve Troup, Maureen Nieces, Mark Roberts, Joe Buissink, Julieanne Kost, Denis Reggie, and Lori Lopez of Wild Orchids The Salon: Each one of you has played a part in not just this book, but our careers and our lives. We get by with a *lot* of help from our friends.

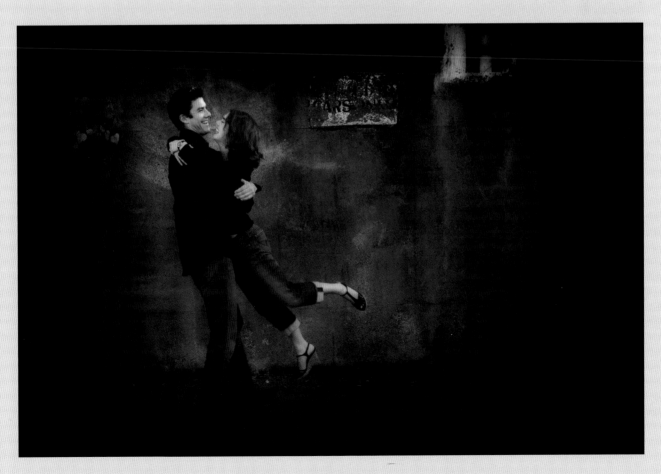

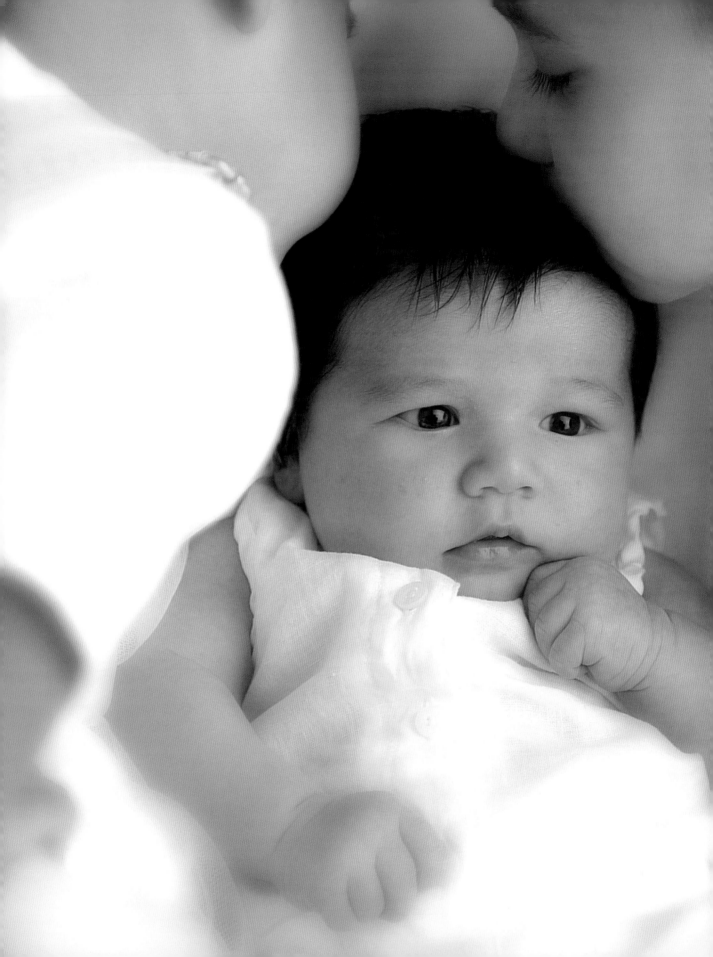

To Tony Corbell

We cherish your friendship,
your support,
and your passion for
photography

contents

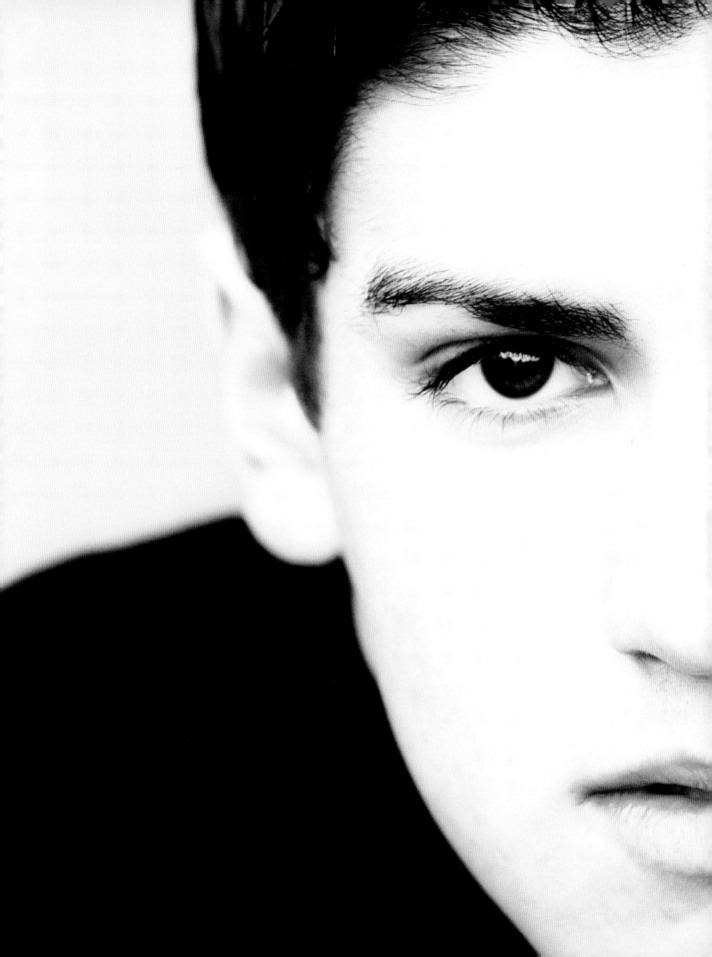

introduction

Anyone can be a photographer— but only a few photographers are artists.

IN ORDER TO BE a great photographer, you need to understand all the tools of the trade. It's imperative to understand every piece of gear involved in the process, from cameras to lenses to films and digital media. Once you've mastered the equipment, you've got to understand composition, lighting, depth of field, and exposure. Then you have to understand the printing process.

Only when you've learned all the rules have you earned the right to break them. All the boundaries of the rules of composition and exposure can go right out the window as you learn to express yourself as an artist. Anyone can be a photographer—but only a few photographers can truly be artists.

When it comes to portraiture, the challenge isn't so much about understanding imaging or your equipment as it is about understanding people. If you can't touch your subject's soul, all you'll be creating is another picture. Portrait photography is one of the toughest of all the photographic disciplines. The people in front of your lens are all you've got to work with, but great portraits aren't just about what people look like. They're about how people see themselves.

On location or in the studio, the final image is about one thing only: the person you photographed. With the click of the shutter, you have to capture your subject's expectations in that one exposure. And it makes no difference whether you're shooting digital or film—if you miss the shot, that's it, you're done.

Bambi Cantrell's imagery is virtually unmatched in the field of professional wedding photography. Each photo is unique. Every couple finishes with an album that completely captures the excitement of the day and the start of a new family. Bambi's lens selection, use of depth of field, lighting, and composition have made her one of the finest wedding photographers of our time. However, if you ask her the secret to her success, she'll tell you it has little to do with photography and more to do with knowing both her market and each person she photographs. It's all about people and capturing the human experience. When asked, "What makes your work so different?" Bambi's response was, "I just love people."

In this book, we're going to take all the same techniques Bambi uses to capture a bride and groom and apply them to portrait photography. From babies to families to corporate executives, we're going to present a series of techniques that takes you beyond photography. In fact, this book isn't about photography at all; it's about capturing the human experience. And keep in mind, creating an incredible portrait is all about passion. You can't capture the passion of your subject if you don't have the passion yourself.

OPPOSITE: 28–70mm lens at 50mm, 1/125 sec. at f/.5.6, ISO 100, Manual mode, main light at f/8, fill light at f/5.6, reflector directly under main light to bounce back into face, Nik Midnight

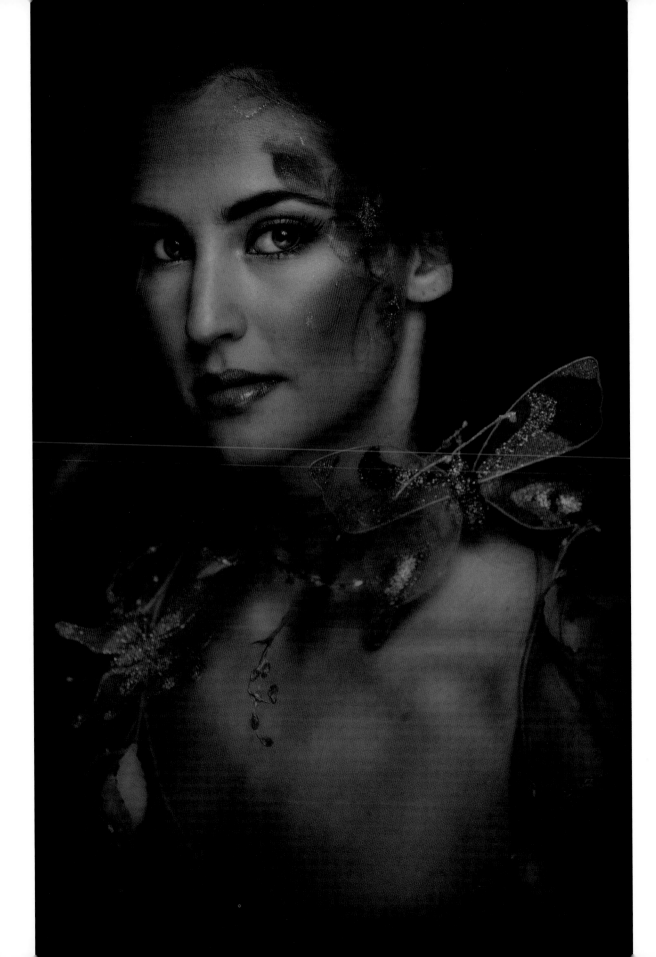

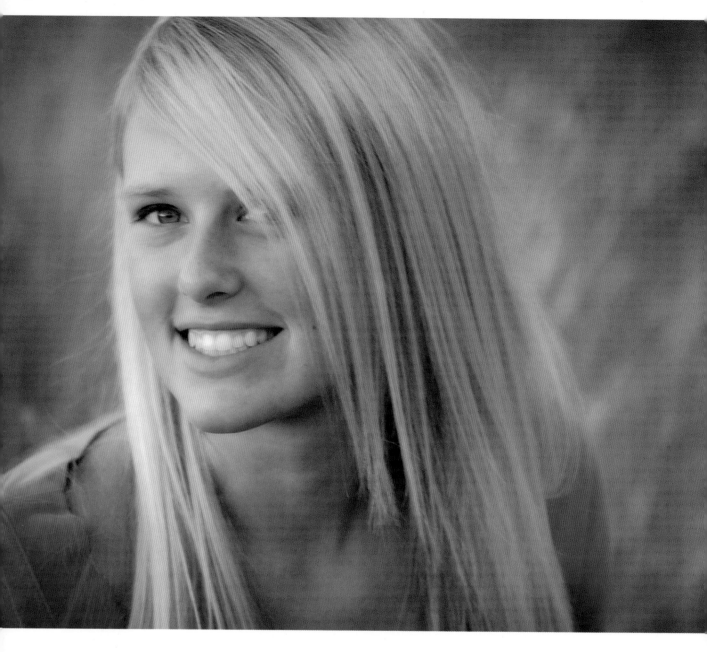

ABOVE: 70–200mm lens at
200mm, f/4.5 for 1/100 sec.,
ISO 100, Aperture Priority mode

OPPOSITE: 70–200mm lens at
75mm, f/2.8 for 1/50 sec., ISO
500, Aperture Priority mode

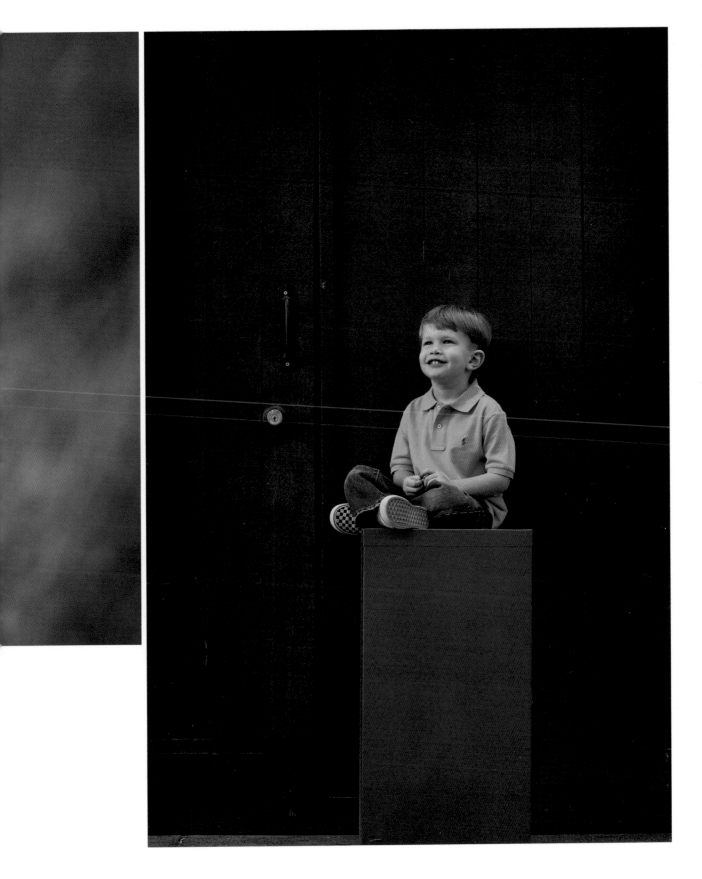

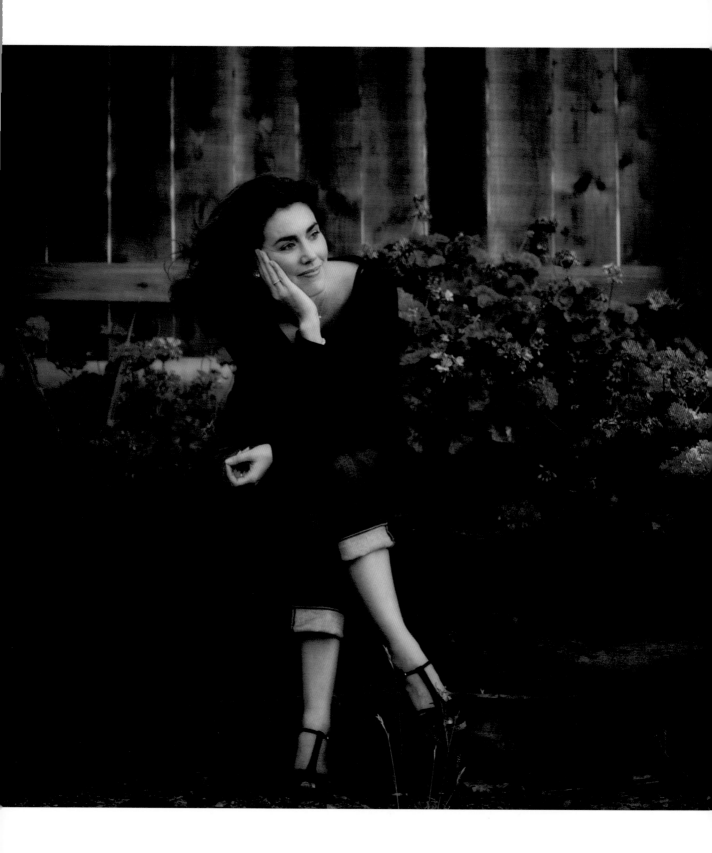

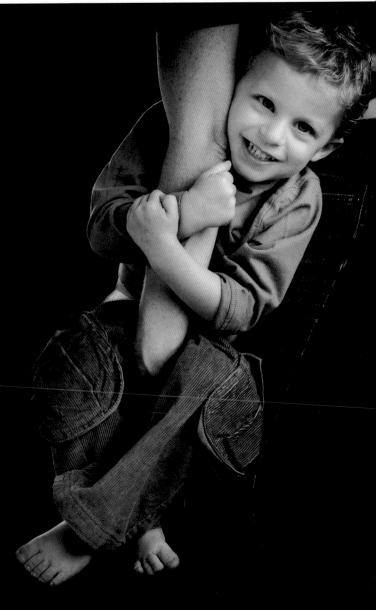

LEFT: 70–200mm lens at 80mm, f/2.8 for 1/100 sec., ISO 125, Aperture Priority mode

ABOVE: 28–70mm lens at 43mm, 1/160 sec. at f/8, ISO 320, Manual mode

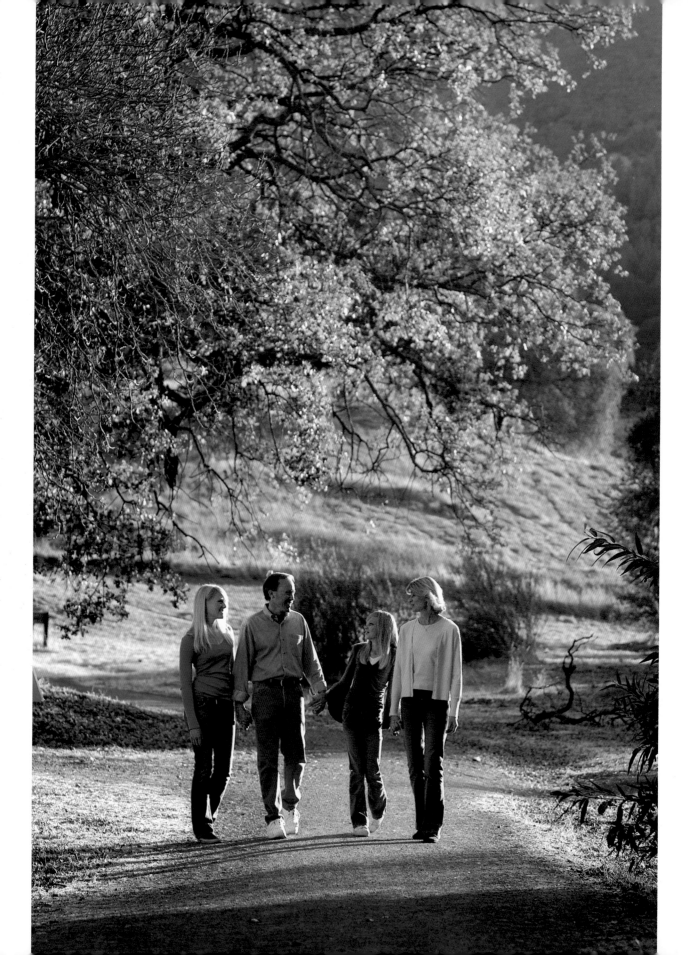

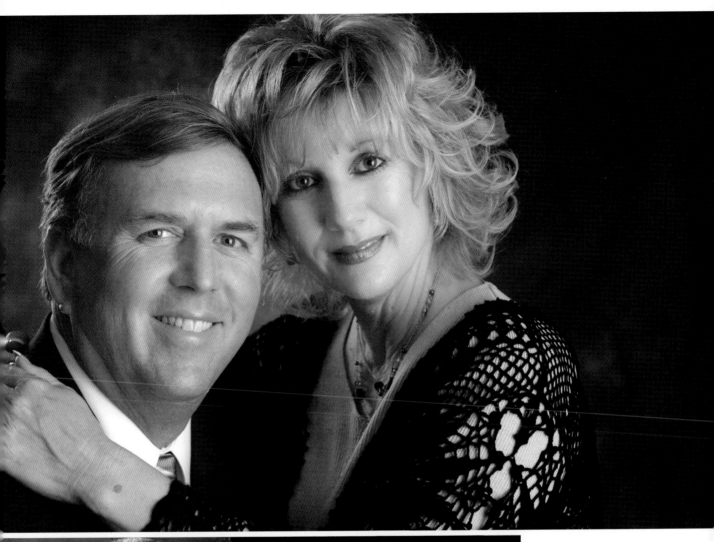

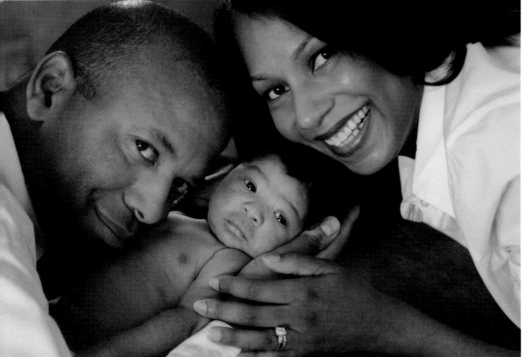

ABOVE: 28–70mm lens at 63mm, 1/80 sec. at f/6.3, ISO 100, Manual mode

LEFT: 28–70mm lens at 70mm, f/2.8 for 1/60 sec., ISO 200, Aperture Priority mode

OPPOSITE: 70–200mm lens at 80mm, f/4 for 1/200 sec., ISO 100, Aperture Priority mode

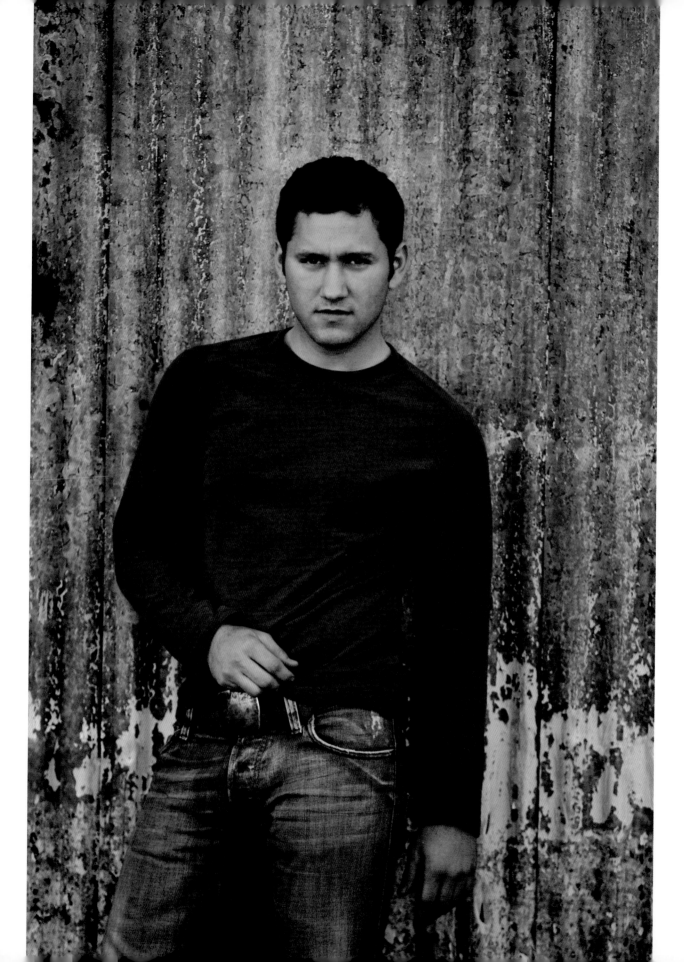

different people, different portraits

There are three main subject elements that differ from subject to subject. First is the sex of the subject. If men are from Mars and women are from Venus, then capturing either sex in a portrait session turns the photographer into NASA's Mission Control Center in Houston! Second is the age of the subject. As men age, they often consider themselves more dignified, while women age and often simply hate the process. Third is the shape of the subject. You'll find yourself using different posing techniques with heavier subjects than you do with thin ones. The goal with any subject, however, is the same: to create a flattering portrait.

applications

BEFORE WE GET into the many differences in subjects, let's start with the intended application of the photograph, because this will affect how you choose to interpret the subject. For example, a head shot of a female executive needs to have a professional look to it. If it's too sexy, it will lose any impact and clarity of purpose. To take it a step further, a real estate agent needs to look friendlier and more inviting than the CEO of a corporation, who needs to look more serious.

As the photographer, you have the ability to create the entire mood of the shot, from totally goofy to breathtakingly dramatic. You can make an executive look more powerful just by photographing from a lower camera angle. You can

This pair of shots of me perfectly illustrates the point that the ultimate application of the photo will affect the style and feel of the image. Years ago, I needed a new head shot (right). As president of Hasselblad USA at the time, I needed the shot to be serious, with a certain sense of commanding control. Bambi made the film image outside a restaurant in Philadelphia. There was no digital manipulation, no special lighting—just a good understanding of the shot I needed and how to get it.

Compare this to the shot opposite intended for purely casual applications. If you consider them as "then" and "now" images, you can see that I'm having a lot more fun today! And one more point: You don't need a fancy studio for portrait work.

RIGHT: Hasselblad 503CW, 180mm lens, T-Max film, 1/125 sec. at f/2.8; OPPOSITE: 14mm fish-eye lens, f/2.8 for 1/500 sec., ISO 100, Aperture Priority mode, Kevin Kubota Photoshop Action Black and White

put a smile in a subject's eyes without eliciting a big, toothy grin. Stay away from the old "Say cheese!" and just get your subject talking. Ask specific questions that draw out information on hobbies, friendships, and favorite experiences. For example, when photographing an engaged couple, you might ask them how they met. Often, you can make a photo more inviting simply by having your subject lean in toward the camera.

It's your responsibility to provide the direction that meets the subject's expectations for the type of requested photograph. Meet the client's mind-set and you've won; miss it and you'll rarely get a second chance—the client simply won't come back.

As the photographer, you have the ability to create the entire mood of the shot.

women

WHEN PHOTOGRAPHING WOMEN, you'll be able to tell a lot about your subject by the way she's dressed. Do the shoes match the bag? Do the nails match the outfit? Women who aren't concerned with these things tell you just as much about their personalities. A woman who is more casually dressed (without matching accessories, for example) simply doesn't sweat the small stuff.

Okay, so now you're wondering, What does that have to do with anything? Well, it tells you how much you can push the envelope. How a woman dresses, how she sits, and how she speaks will let you know how contemporary you can make the image. Even in wedding photography, a bride is nothing more than a woman in

a white dress—but the style of the dress and the attitude of the bride dictate whether the images you create are going to be more traditional or contemporary.

Weight, hair, makeup, and age will all be issues with every person you photograph to some degree. While society might let men "age more gracefully," all of us typically perceive ourselves as thinner and younger than the image the camera might capture. So, the challenge is using lighting, posing, and exposure to your advantage to create the most attractive and appropriate image possible. It's all about matching the mind-set of your client with regards to how they perceive themselves.

Sometimes, the application of the final image will dictate the style of the photograph. The image at left was used for a very straightforward business brochure, while the image at far left was a glamour/fantasy shot for a hair salon.

LEFT: 70–200mm lens at 180mm, 1/125 sec. at f/11, ISO 100, Manual mode, fill light at f/8, reflector directly under face; FAR LEFT: 70–200mm lens at 200mm, f/2.8 for 1/60 sec., ISO 100, Aperture Priority mode

men

MEN GENERALLY APPROACH having a portrait taken with all the enthusiasm of getting a root canal. Both men and women need portraits taken for business use, but women also are more likely to commission photography for other, nonbusiness applications. Often, the application for a man's portrait is more business oriented than casual. So, the application of the image is more critical: Is it for a catalog, an annual report, or the local newspaper, for example?

While vanity plays a role with both men and women, men are generally less concerned about their weight, wrinkles, or hair color. They perceive themselves as aging gracefully, while women simply want to slow down the clock. This reflects

Different lighting, whether natural or artificial, completely changes the mood of the final image. Harsher lighting gives an image a more interesting perspective, especially on a male subject.

RIGHT: 70–200mm lens at 153mm, f/5 for 1/160 sec., ISO 500, Aperture Priority mode, Kevin Kubota Photoshop Action Black and White; FAR RIGHT: 70–200mm lens at 70mm, f/2.8 for 1/125 sec., ISO 100, Aperture Priority mode

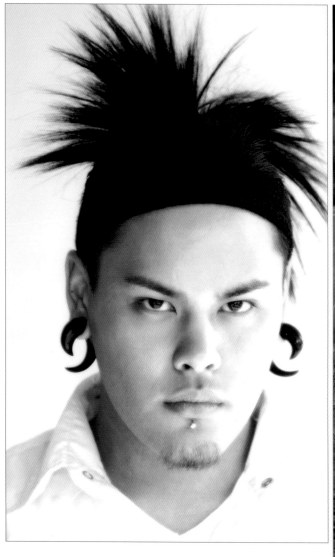

society's double standard, unfortunately. And let's not forget the buzzword *metro-sexual*. Don't be the least bit surprised if many male clients are even more concerned about grooming than any female. The sexes are getting closer together—and closer to finishing in a dead heat when it comes to vanity. Of course, whenever you generalize, you're taking a bold step into stereotypes once more, but we find that they're pretty accurate when working with men or women in the studio or on location.

With both female and male subjects, remember that your camera angle can make them look strong and commanding or weak and wimpy. Lighting can soften subjects or make them look sinister.

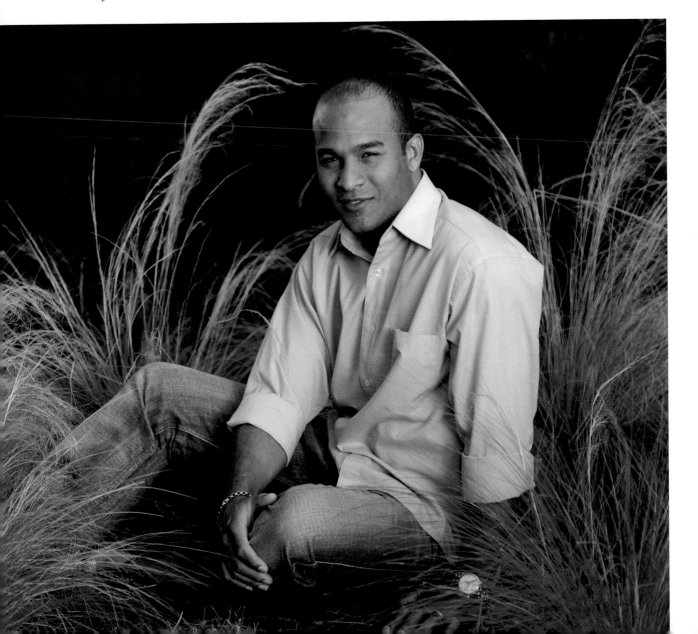

children

OUR NUMBER ONE TIP with children is to try to mirror the way your subject is behaving. If children are quiet and sullen, follow their lead. Talk quietly, and bring yourself physically down to their level. For example, you might start out photographing while lying on the floor to enhance your subject's comfort level. If your subject is outgoing and gregarious, get a little goofy, and join in the fun. The most important rule is that there are no rules. Get mom and dad to understand that there's nothing the child can do wrong in a portrait session and you've won half the battle.

You also have to recognize the personality of the child you're photographing. Just let children talk and act as they do—don't make them do tricks that don't seem natural to their personality. Pay attention to the nonverbal, and you'll understand all you need to know about your subject.

There's no limit to the number of toys, puppets, and stuffed animals you need in the studio. Children have a short attention span, and it might take a new toy or technique every time. *Time* is *not* on your side when you work with children; you've got to move fast, get the shot, and move on.

The real key to photographing children is the simplicity of your equipment. Since your time is going to be limited, you can either fool around with your gear and risk losing the shot, or have one camera set up the way you want it—in advance—and get the shot on the first take.

> **With children, the most important rule is that there are no rules.**

Bambi took all these images on location. Children are most comfortable in their own environment.

RIGHT: 28–70mm lens at 50mm, f/2.8 for 1/50 sec., ISO 100, Aperture Priority mode, Kevin Kubota Photoshop Action Black and White; OPPOSITE TOP: 28–70mm lens at 35mm, f/2.8 for 1/60 sec., ISO 400, Aperture Priority mode, Kevin Kubota Photoshop Action Cross-Processed, photo © Michael Van Auken; OPPOSITE BOTTOM: 70–200mm lens at 200mm, f/2.8 for 1/30 sec., ISO 400, Aperture Priority mode, increased contrast by 20%, photo © Michael Van Auken

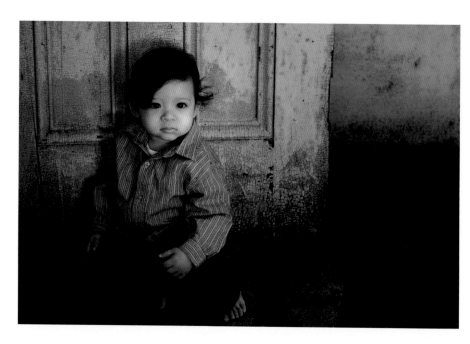

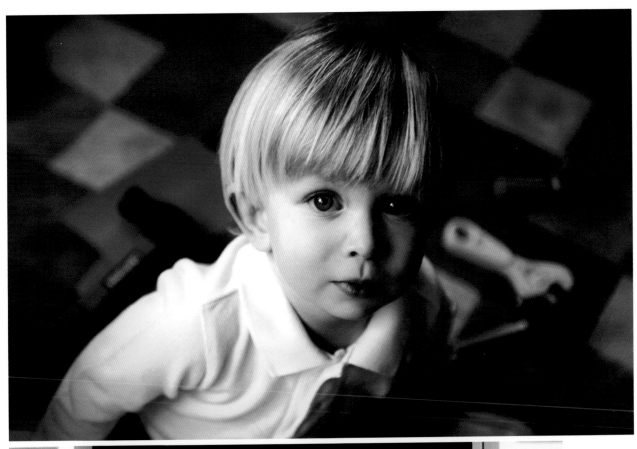
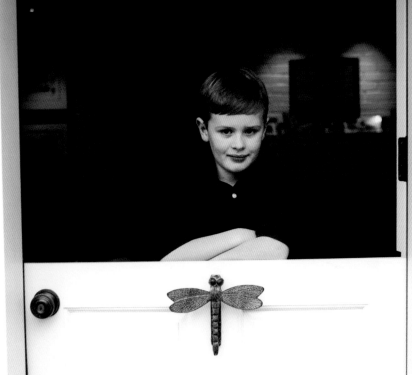

babies

YOU'RE A SCULPTOR working with a raw piece of clay when it comes to the posing of babies. Bean bags become an important asset in helping position your subject, while soft sounds will be soothing and may elicit just the facial expression you're after. Soft lighting becomes critical in helping the baby relax, and again, time is of the essence.

Also, keep the purpose—the application—of the image in mind. It's especially important to understand the expectations of the parents when photographing

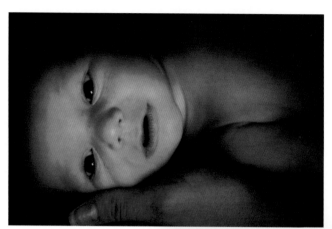

a baby. Are they more interested in capturing the interaction between themselves and the baby or what they perceive as the baby's already blossoming personality? Or, maybe it's a combination of both.

Don't be afraid to think outside the box and try some new things with each shoot. With babies, it's often the case that what the parents end up liking the most is miles away from what they originally told you they wanted.

There really are no steadfast rules when it comes to photographing infants, except one: Get them to relax and interact with you or their siblings, and you've got it. You need to be on their level, work fast, and concentrate on the simple things. Keep your backgrounds as uncluttered as possible and just look for the expression.

ABOVE: 70–200mm lens, f/2.8 for 1/60 sec., ISO 200, Aperture Priority mode; RIGHT: 70–200mm lens at 200mm, f/2.8 for 1/60 sec., ISO 100, Aperture Priority mode; OPPOSITE: 28–70mm lens at 70mm, f/2.8 for 1/30 sec., ISO 100, Aperture Priority mode

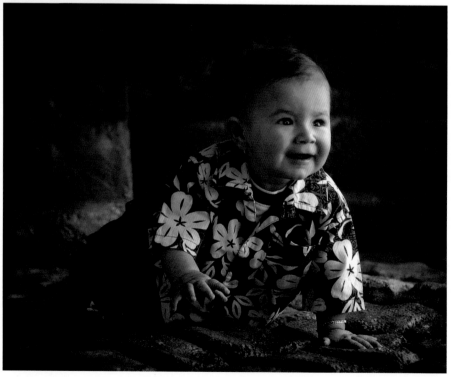

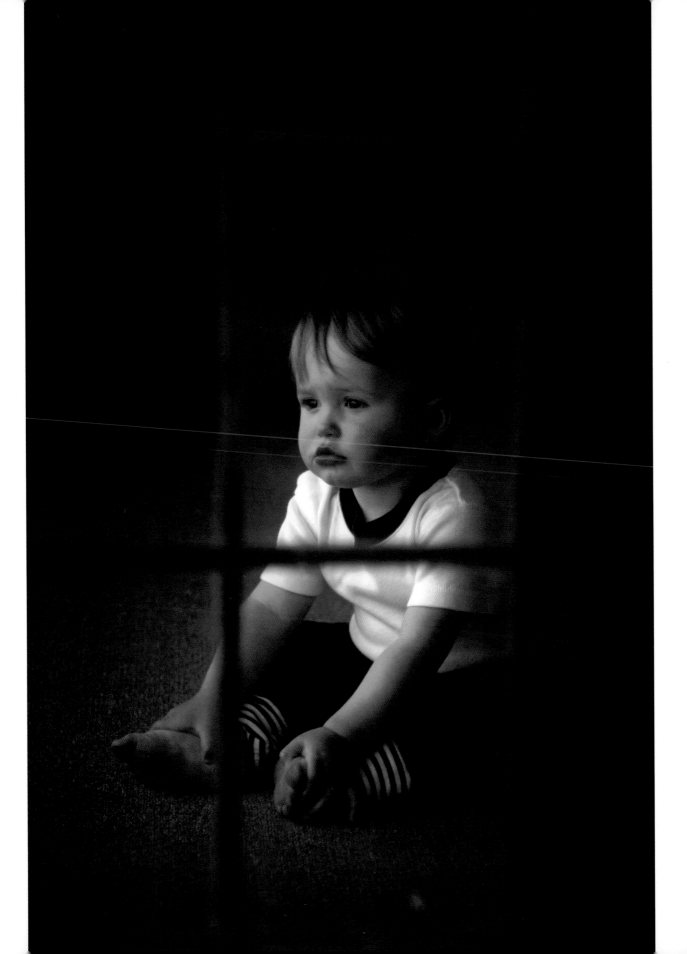

high school seniors

UP UNTIL ABOUT ten years ago, almost every senior portrait was as boring as the next. Every photograph was, typically, a head shot and rarely captured the essence of the subject. Today, high school seniors have become one of the fastest-growing segments of the portrait photography business, and this increase is a result of the influence of fashion, television, and print advertising. There's a new attitude, and it's all about individualism. Teens may follow trends and one another's styles like crazy, but they see themselves as unique. So, get to know your subject.

Think back to when you were eighteen. In most cases, you displayed anything but self-confidence. However, if somebody got you talking about your hobbies, sports, music, your friends—whatever got you pumped—your whole personality changed. Your individualism came out. Now, apply that same philosophy to the portrait session. If there is one word that complements *individualism*, it's *energy*. You've got to create an atmosphere, both physically and with your own personality, that allows your teenage subject the freedom to simply take over the portrait session.

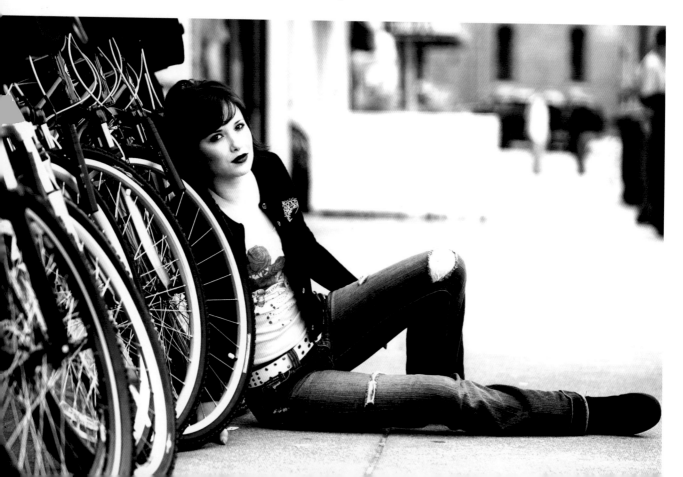

There's a new attitude, and it's all about individualism.

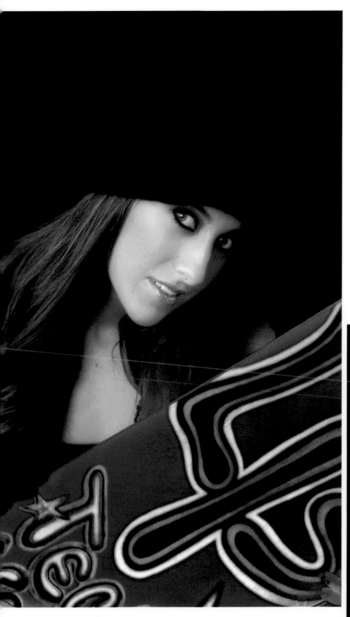

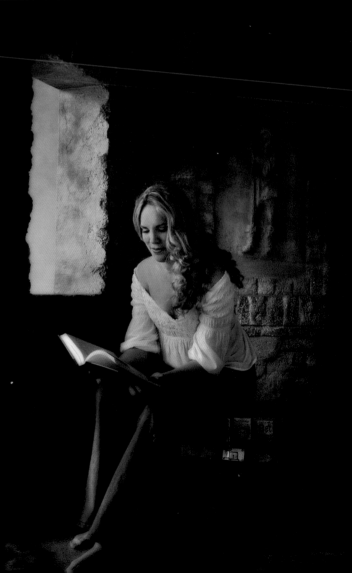

Seniors have multifaceted personalities, and it is important to help them show their individuality.

OPPOSITE: 70–200mm lens at 200mm, f/ 2.8 for 1/60 sec., ISO 100, Aperture Priority mode, Kevin Kubota Photoshop Action Cross-Processed; ABOVE: 70–200mm lens at 100mm, f/2.8 for 1/15 sec., ISO 400, Aperture Priority mode, Nik Saturation to Brightness; RIGHT: 28–70mm lens at 35mm, f/2.8 for 1/30 sec., ISO 400, Aperture Priority mode

families

AGAIN, WITH FAMILIES as your subject, you should approach the photo session with the purpose of the photograph in mind. Is the image being used for a holiday card or for a 30 × 40–inch wall portrait, for example? There are also other considerations: How do the members of the family interact? Are pets a part of the family? Photographing a family is about capturing the personality of the family and being able to convey the family's connection.

If high school seniors are the fastest-growing segment of today's portrait photography market, then families are the segment that's the toughest to capture successfully. You need to ask yourself if the way you've grouped the

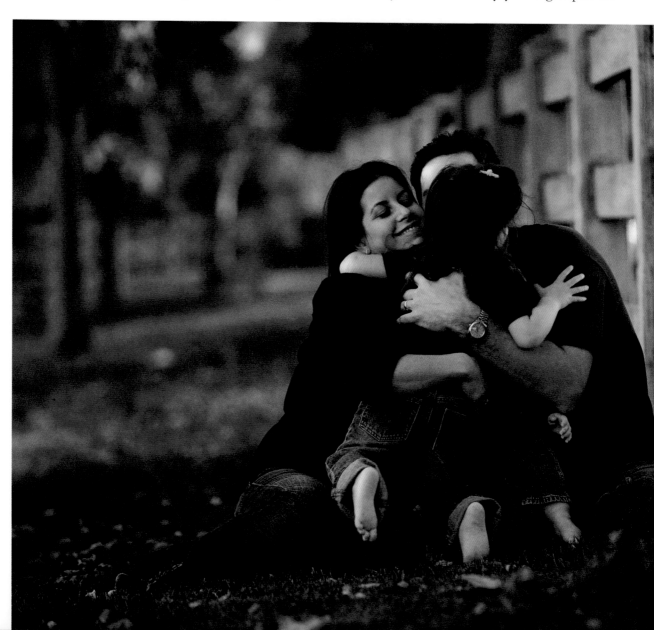

family allows the personality of each individual to come through. You have to pay attention to each family member. On location or in the studio, it's your job to establish each family member's comfort level. Everyone has to look good in his or her own eyes—*not* yours.

Understanding posing and composition is critical, but you have to understand your subject and balance perfection with expression. The most perfect pose in the world is a loser if you worked so hard to get it that you lost the expression in the face. Expression is the Holy Grail of people photography—everything is forgivable except bad expression.

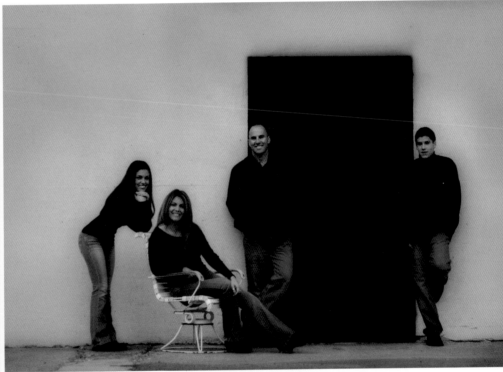

Today's families are into a more relaxed, contemporary look for their portraits.

LEFT: 70–200mm lens at 200mm, *f*/2.8 for 1/60 sec., ISO 400, Aperture Priority mode, Kevin Kubota Photoshop Action Black and White; ABOVE: 70–200mm lens at 100mm, *f*/2.8 for 1/30 sec., ISO 100, Aperture Priority mode, Nik Midnight

couples

WHEN YOU'RE PHOTOGRAPHING a couple, it usually means you're taking an engagement portrait. Out of all the various types of subjects (at least, of human subjects), couples can be the easiest to photograph. You just have to take the time to get to know them. And, it's all about romance, mood, and, as hokey as it sounds, love.

It's interesting that the key to having a successful engagement portrait photo session has little to do with how good an image you capture. It is more about taking the opportunity to get to know your subjects—and, in turn, having them

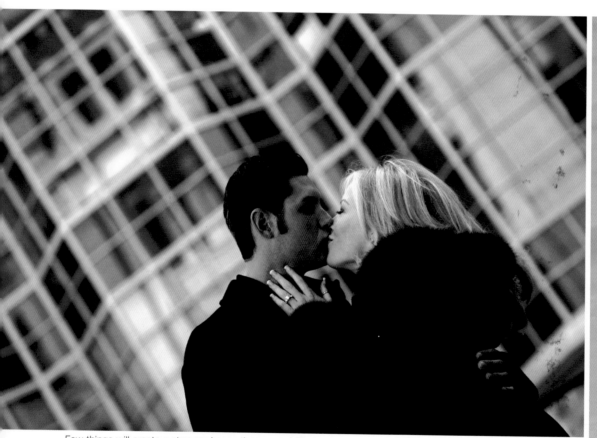

Few things will create a stronger image than your ability to capture the interaction between two people.
ABOVE: 70–200mm lens at 200mm, f/2.8 for 1/60 sec., ISO 100, Aperture Priority mode, Nik Monday Morning; RIGHT: 70–200mm lens at 200mm, f/2.8 for 1/30 sec., ISO 400, Aperture Priority mode

get to know you. It's about getting them to relax while they're working with you and to understand that you're there simply to capture the moment—not create it. Most important of all, if you do things right, the photo session reduces the pressure of the unknown when it comes to the wedding day!

A natural environment will give you a different series of images to work with than a formal studio session will. A natural environment also allows the subjects to more actively interact. Again, it comes back to recognizing the purpose of the photograph and the expectations of the couple.

It's all about romance, mood, and love.

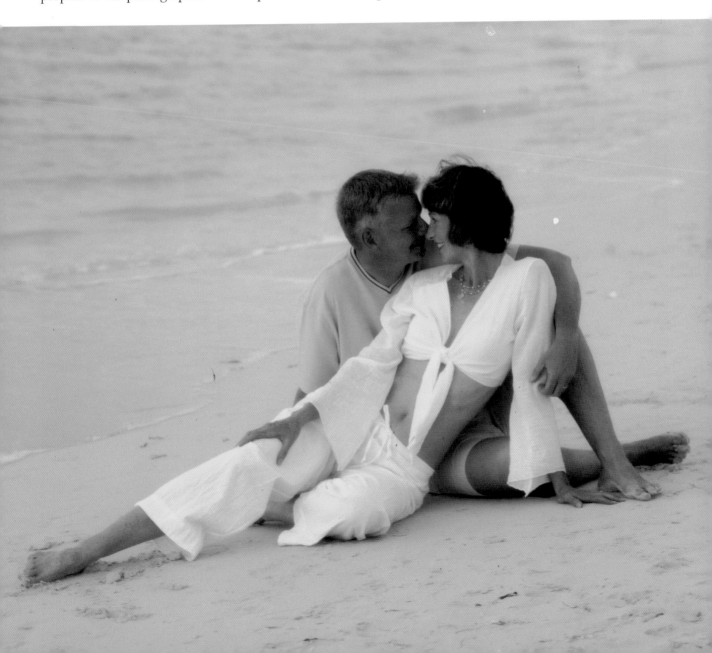

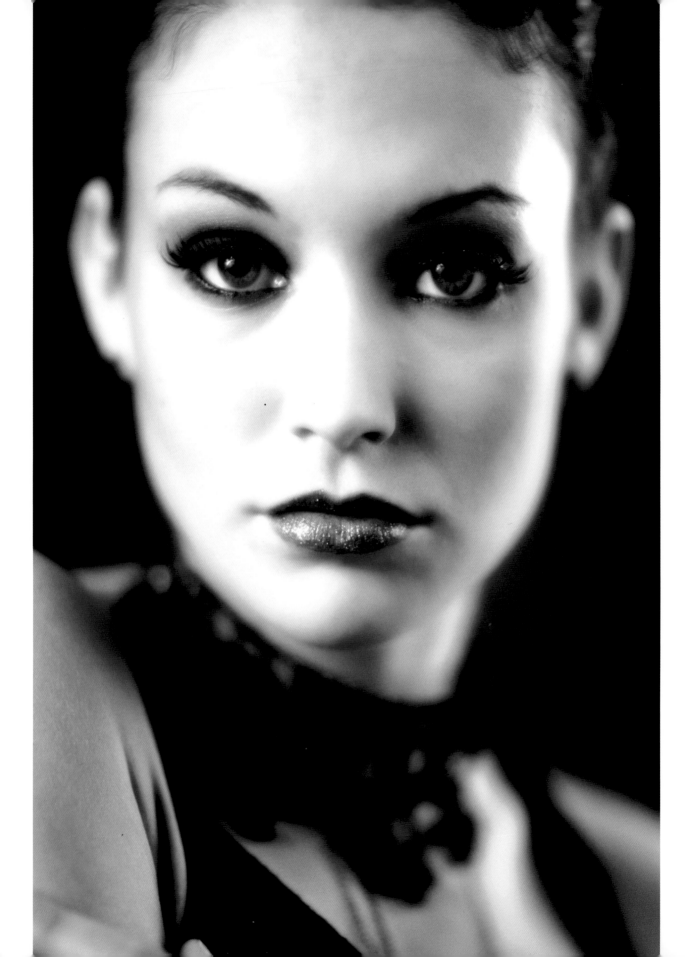

equipment

Cameras don't take pictures—
people do. But, as a professional photographer, you need to start with the right equipment and then understand the importance of knowing how and when to use it. The right equipment takes the guesswork out of the assignment and allows you to create the finest possible images without second-guessing whether or not you got the shot.

There's another reason for the right gear: There's nothing worse than spending money over and over again because you decided to save a buck the first time out and bought the cheap stuff! You get what you pay for, and your clients get what they pay for when they hire you.

camera bodies

THERE ARE A FEW major reasons for working with the Canon Mark II, which is Bambi's camera body of choice. First, the metering is deadly accurate. Second, it's fast in terms of capture rate. Third, it's a little heavier than other models; Bambi creates a lot of her work at slower shutter speeds, and a camera that's more substantial is easier to hold steady.

In addition, Bambi always takes two camera bodies on every assignment. The major reason for this starts with Murphy's Law: Everything that can go wrong will. Better yet, there's Bambi's Law: Murphy was an optimist! Whether you're working with film or digital, you never know when even the very best gear is going to have a problem. You can't plan the unexpected, but you can be prepared for it. Another good reason for always having more than one camera body on hand is that there are times when you've got to work so fast you don't have time to change lenses. Having two cameras set up with different lenses gives you the ability to work much faster.

If you're just coming into portraiture and trying to decide what's important in your next camera purchase consider the following:

- Fast focus speed
- Optically fast lenses
- Chip and file size
- Reliability
- Lens selection

> **You can't plan the unexpected, but you can be prepared for it.**

camera bag necessities

The following list runs down Bambi's camera bag necessities. You might have other equipment or items that you can't work without, and that's fine. This will just give you a good starting point.

- 2 Canon EOS-1D Mark II camera bodies
- Canon 70–200mm F2.8 IS lens
- Canon 27–70mm F2.8 lens
- Canon 85mm F1.2 lens
- Delkin CompactFlash cards (512MB or 640MB). Generally, you can plan on using one card per portrait session, as compared with twenty to thirty cards for a wedding.
- ExpoDisc white balance filter
- 60-inch Westcott five-in-one reflector (white, silver, black, gold, and translucent)
- Quantum Qflash dedicated flash

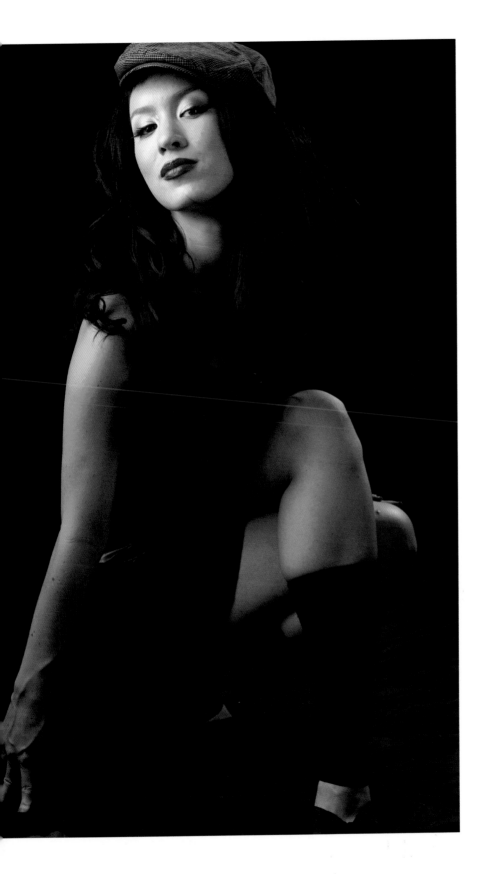

why Canon?

Canon, over the past few years especially, has taken a dedicated stand to provide the professional photographic community with the very best products for its craft. In addition, speed is an issue for Bambi: "In working with children, I've got to have a camera that focuses fast! I've got no time to [fool] around waiting for my camera. In fact, with a burst rate of 8 frames a second, [Canon is] ideal for capturing images of children. I'm simply *never* let down!"

Durability is another issue, as Bambi (like any photographer) is dragging her equipment everywhere. She likes the weight of the cameras—they're solid and they're versatile. Lastly, just about everything is interchangeable, allowing Bambi to regularly upgrade to camera bodies with new features while still being able to use a variety of Canon lenses. Technology is constantly changing, and you want equipment that will give you room to grow and let you take advantage of every new feature available—without having to start over with completely new gear each time.

A heavier camera is easier to hold steady at slower shutter speeds, such as 1/60 sec., which is what Bambi used here.

Canon EOS-1D Mark II camera body, 1/60 sec. at f/6.4, ISO 200, Manual mode

lens selection

YOU REALLY NEED only three lenses for portrait work. Obviously, if you can afford only one lens, then you'll find the best ways to use that single lens, but if you are able to buy more than one lens, you should. Sure, you could do the job with only one lens, but why would you want to? The bottom line is, these are the tools of your trade and the things that give you the most versatility.

28–70mm

The 28–70mm lens is ideal for working with family groupings. It's wide enough to give you the coverage you need both in the studio and on location. The Canon 28–70mm is a good, solid bread-and-butter lens, and as an F2.8, it gives you a nice, shallow depth of field.

70–200mm

A selection of some of Bambi's equipment, including her light meter, some lenses and CompactFlash cards, one of her camera bodies, and an ExpoDisc filter.

The Canon 70–200mm is Bambi's favorite lens. The focal length enables her to move away from her subject and be just an observer. The narrow field of focus becomes ideal for concentrating on things like baby "parts," giving Bambi the ability to isolate elements of a subject (for example, the emotion in a baby's face). It's ideal for working with newly engaged couples, again due to its ability to let the photographer capture subjects' faces without actually being in them.

85mm

The Canon 85mm is Bambi's secret weapon. Since it's so versatile, it's perfect for working in low-light situations, tight quarters—any situation that's less than ideal. Because her 85mm is an F1.2 lens, it allows her to be more interpretive if she chooses to shoot wide open, and it can attain such a narrow depth of field that only one eye of a subject might be in focus.

other choices

When it comes to other lenses, the more you have, the more you can play. If you've got the basics and are thinking about adding another few to your stash, take a look at the 300mm F2.8 and a fish-eye lens. They're simply fun to have. You won't use them all the time, but you'll find enough reasons to always have them with you.

With the 300mm F2.8, you'll find you have the ability to be almost invisible in a portrait session. This is ideal when working with engaged couples or when capturing the interaction between a bride and her father walking down the aisle. It's ideal for fashion photography, with incredible compression; higher compression of the background allows you to better isolate the subject.

Then there's the fish-eye. This lens is simply a kick! While it can be an ideal tool for environmental portraiture in a small area—for example, in an office environment—Bambi prefers to just have fun with it.

These are the lenses that give you the most versatility.

other accessories

IN ADDITION TO the basics, there are a few other necessities when it comes to digital work. The ExpoDisc is important to your camera being able to establish a definition of "white." Unless the camera has a standard to calibrate against, there's no chance of accuracy with any of the other colors in the spectrum. To use the ExpoDisc, you snap it on to the front of the lens, set the camera to custom white balance, and snap the shutter—that's it.

Profoto has been Bambi's studio light choice for many years. The company simply makes great products. They're lightweight, portable, reliable, and the foundation for an easy-to-use system. They're also consistent in the quality of light they create and can be altered in 10 percent increments.

studio necessities

In addition to camera-bag equipment, there are the necessities for the studio, primarily lighting and backgrounds.

- Profoto D4 2400 power pack
- 4 Profoto Acute/D4 flash heads
- 4 × 6–foot softbox
- 1 × 4–foot softbox
- 2 Profoto 5-foot reflectors
- Sekonic L-558R light meter
- 3 Profoto light stands
- Backgrounds by Maheu photo backgrounds. Two to three different ones will cover the basics for almost every style of image.
- Off the Wall background/scenery photo set (Villa series)

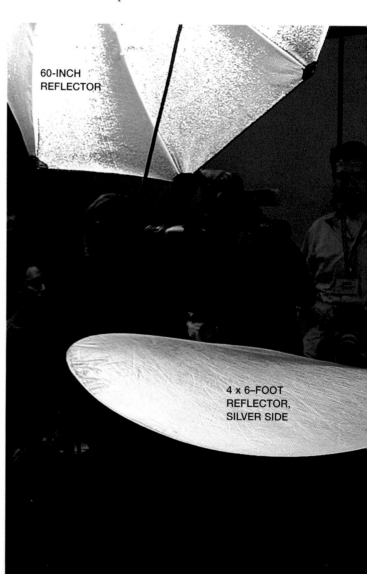

60-INCH REFLECTOR

4 x 6–FOOT REFLECTOR, SILVER SIDE

It's nice to always have at least one softbox. A softbox diffuses and softens the light. Bambi's favorite is 4 by 6 feet. The larger the light source, the softer the light.

Everybody wants to have a dream studio with incredible sets; lots of texture and color; and the particular style for your type of portrait work, but we don't all have access to the funds necessary to build beautiful sets to the level of diversity we'd like to have. Off the Wall has developed a complete series of lightweight backgrounds, giving Bambi's studio portrait work looks that range from an Italian villa to a red brick wall. Now, put Off the Wall's products together with the beauty of David Maheu backdrops and you've got the best of all worlds, with maximum beauty and versatility.

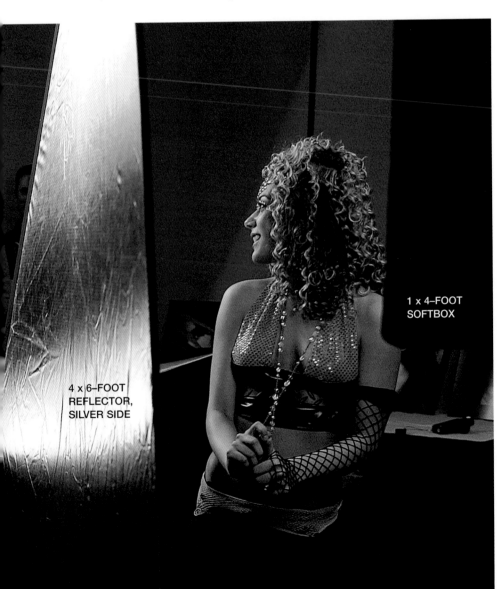

1 x 4–FOOT
SOFTBOX

4 x 6–FOOT
REFLECTOR,
SILVER SIDE

Having a variety of reflectors in your bag will maximize your creativity in virtually every situation.

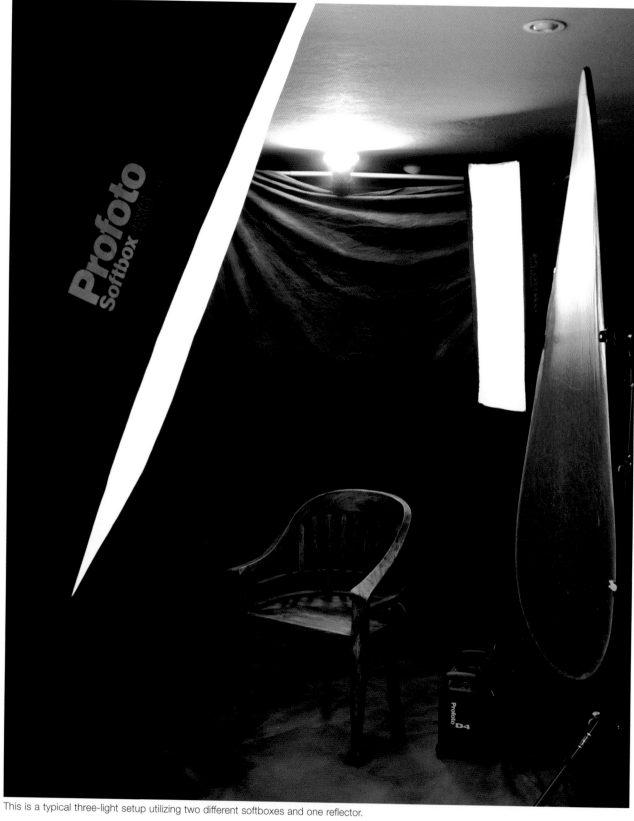

This is a typical three-light setup utilizing two different softboxes and one reflector.

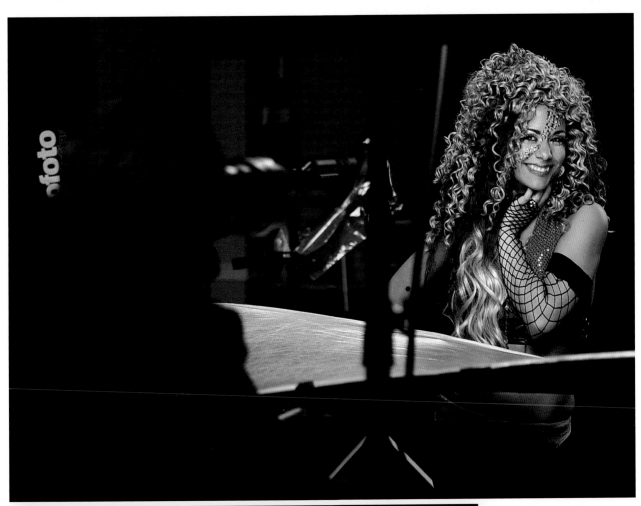

ABOVE: "Clam shell" lighting, shown here, creates a very flat light source. Flat lighting is ideal for creating the most flattering glamour shots.

LEFT: If you're working with babies and children, you'll need some toys on hand. Your selection of baby toys could include balls, puppets, dolls, feather dusters, and anything else you can find— even cat toys! Cat toys are perfect for distracting babies.

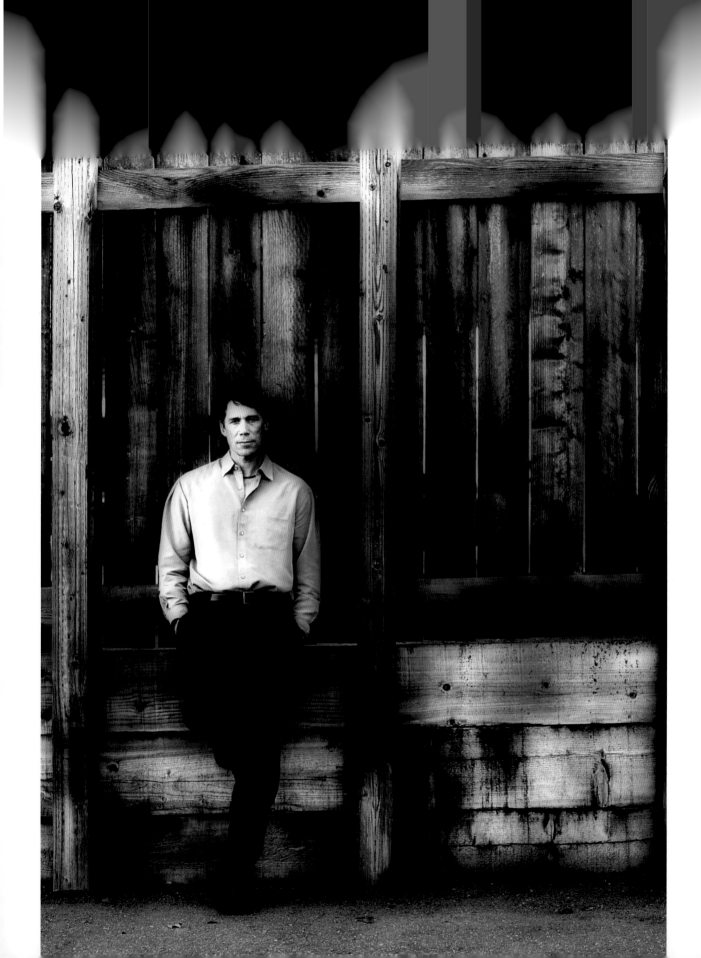

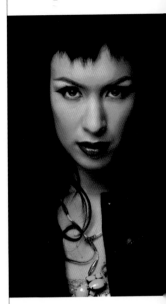

men & women

Let's start with a few points

about men and women and portraiture. First, women make the majority of purchasing decisions when it comes to professional portraiture. Men just aren't as involved, although they may be the recipient of a family portrait for a Father's Day or birthday gift. So, right off the bat, if you're advertising only in *Guns & Ammo* or *Field & Stream* magazines, it might be time to regroup!

Second, the way men and women approach sitting for their own portrait is often different. While you shouldn't always generalize, and the following may not always be true, Bambi has found that women are usually much more vocal about what they perceive as imperfections in their appearance, while men are more no-nonsense, adopting a let's-just-get-it-done attitude. And third, men and women are equally emotional when it comes to the results of their shoots, or as Bambi recently put it, "Some of my best criers are men."

first, the men

IF YOU HAVEN'T HAD A CHANCE to actually meet with your subject before the photo session, then at the session, take the time before you start clicking to talk with your client. You have one job here: to get to know your subject. You need to understand what the portrait is going to be used for, as well as what your subject does for a living—in case this informs who he is. (This also applies to female subjects.)

Once you know the reasons behind the need for a portrait, you can begin to think through how best to portray your subject. For example, a lower camera angle will make subjects look taller and more commanding. Having subjects sit or lean against something might make them look more casual or approachable. You must decide which interpretations are best suited to the end use of the photograph.

sex specifics

More dramatic lighting on a man will bring out facial lines and add more character to the image. It's going to be just the opposite when photographing most women. If you want both male and female subjects to look more powerful, have them look straight down the barrel of the lens. (Other camera angles might add power to an image, but they will also add more weight to your subjects.) Whether or not you do this depends on the personality of the subject and how good a job you've done reading the subject's mind-set.

Photographing a male subject from above, looking down on him, can make him look squat and, possibly, comical. Using the same camera angle with a woman tends to make her appear softer and approachable. And, no matter what the nuances, remember one thing, as the late photographer and teacher Dean Collins used to say: "Beauty is in the eye of the checkbook holder."

Having the sitter lean in, even slightly, toward the camera makes the subject look more interesting and approachable. It's also a prime technique for getting rid of a double chin.

Don't underestimate the importance of knowing how to create the bread-and-butter business portrait. Not every head shot is going to give you room to create mood, mystery, and sex appeal. In fact, the majority of the business portraits you'll do are just good, solid, well-lit images that pick up a level of sincerity and integrity in your subject. It's a simple, three-light setup in the studio, and it's a "must-know" for a portrait photographer. Start with your main light positioned approximately 45 degrees from the camera to the right or left of the subject. Set up your background light on a small light stand facing the background. And, set up your fill light behind you and the camera to fill in the shadows on the face created by the direction of the main light.

70–200mm lens at 160mm, f/2.8 for 1/30 sec., ISO 200, Aperture Priority mode

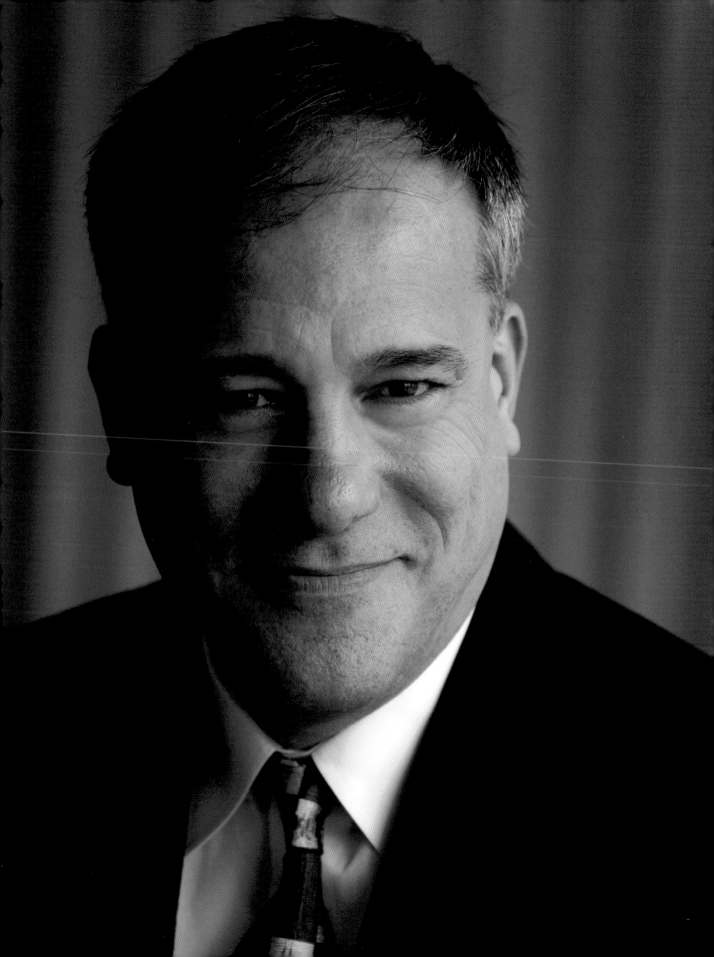

on to women

IT'S NOT THAT THINGS CHANGE so much when photographing women; rather, the range of possibilities becomes so much greater. Again, while every person and situation is unique, we've found the following to be true: Women are more social. They're the family historians in our culture. They'll spend far more time preparing for a portrait than a man will, and in turn, typically give the photographer more time to create it. Since women make most of the purchasing

s when it comes to professional photography (Kodak studies show men s than 10 percent of photo purchasing decisions), they're also more d in working to get the look they want. The older the subjects, the they want to look, while the younger the subjects, the older they want r. And, when it comes to their portraits, they're looking to capture a d an emotion, not just a likeness of themselves.

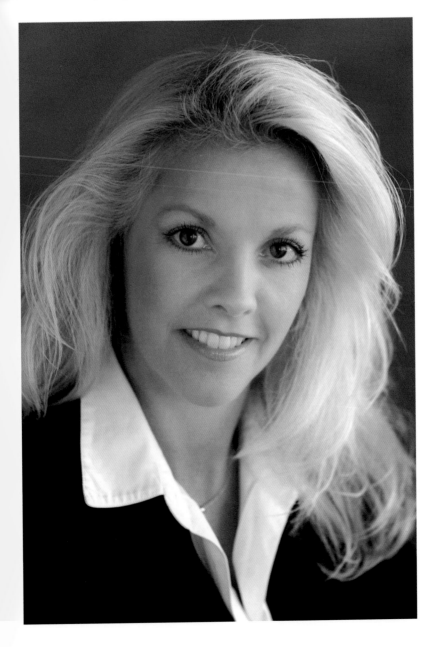

The moods of these two images are very different due to light, pose, and expression. These three components work together to create the emotion of the portrait.

Note that the special digital effects in the images here come from Photoshop plug-ins made by Nik. (Plug-ins are additions to software programs that you can download from Web sites or buy.)

FAR LEFT: 70–200mm lens at 150mm, f/2.8 for 1/15 sec., ISO 100, Aperture Priority mode, Nik Midnight; LEFT: 70–200mm lens at 200mm, f/2.8 for 1/60 sec., ISO 100, Aperture Priority mode, Nik Black and White

creating a mood

Creating a mood starts with the lighting and finishes with the pose. Just like building a house, creating a portrait requires a good foundation. Light is the foundation for the portrait here. And, you have to understand the impact of light in order to work with it. Flat light is one of Bambi's favorites, because it tends to be more flattering to a woman, giving a softer rather than a harsher and defined look. When it comes to the pose, you need to "bend" women. As silly as it sounds, for women, a turn of the hip or a slight bend of the elbow results in an image with a totally different look than a straight-on shot provides.

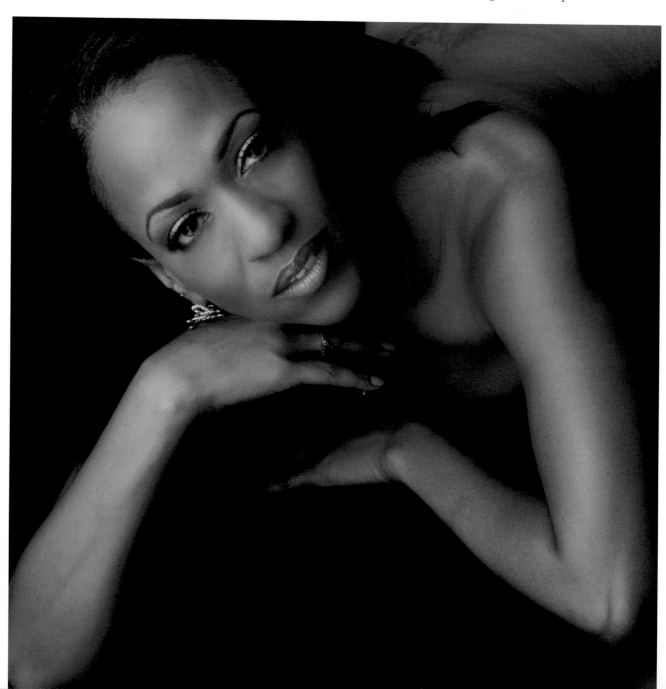

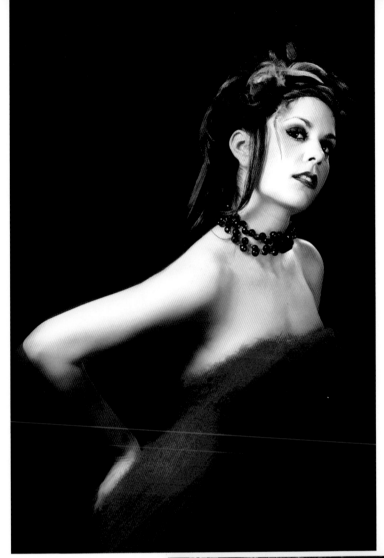

Each of these three images has a different look, starting with the lighting. But that's only the beginning. The next two ingredients are the pose and the facial expression, and they are closely related. The pose will affect the expression, and a change in pose will cause a change in expression. Together they give the subject that unique attitude.

OPPOSITE: 28–70mm lens at 70mm, 125 sec. at f/5.6, ISO 100, Manual mode, reflector (directly under main light to flat-light), Nik Black and White; BELOW: 70–200mm lens at 200mm, f/2.8 for 1/125 sec., ISO 100, Aperture Priority mode; LEFT: 28–70mm lens at 70mm, f/2.8 for 1/10 sec., ISO 400, Aperture Priority mode, Nik Color Infrared and Photoshop Motion Blur

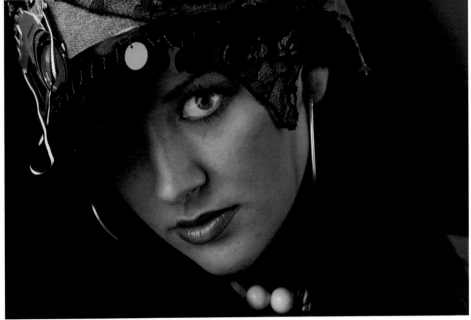

posing women

The number of poses, and combinations of twists and turns, possible with the female form is almost unlimited, but here are some easy-to-remember posing tips.

- As a general rule, shift the subject's hips one way or the other to accentuate the curves of the waistline.

- If there's a joint, bend it, and move the arms away from the body.

- When giving direction to your subject, be specific about which body part you want moved.

- Turn your subject's feet and hips away from the light source. This will make her look slimmer.

- Expression is king— whatever it takes, your ultimate goal is to go for the expression. From the Book of Bambi: Expression over perfection!

Notice the slight bends at the waist and hip, along with the angles of the wrists. Even though they are subtle, these changes in direction *make* the pose.

28–70mm lens at 50mm, *f*/2.8 for 1/60 sec., ISO 100, Aperture Priority mode, Kevin Kubota Photoshop Action Cross-Processed

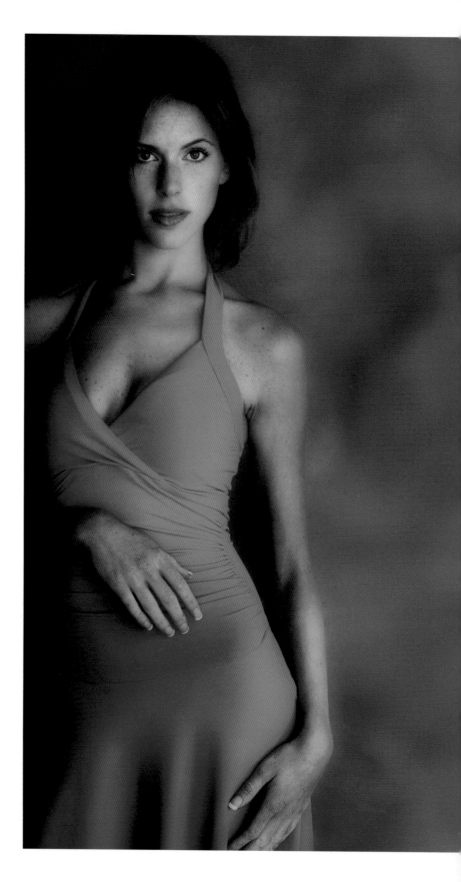

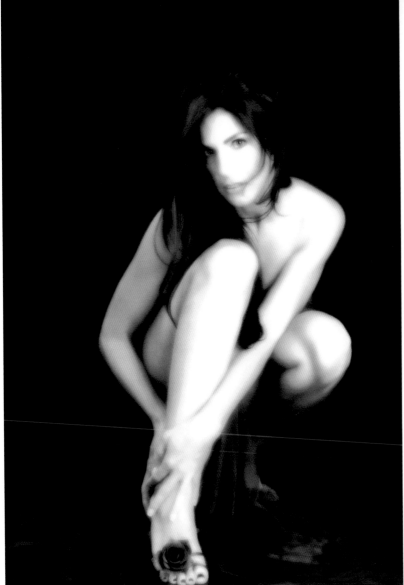

Most important of all, if you and your subject aren't having fun in a portrait session, you're doing something wrong.

LEFT: It's all about variety—and not rigid rule following—in posing and capturing a mood. While the arms aren't held away from the body, the shadows and slight piece of fabric create separation. Diffused Glow, one of the standard Photoshop filters, adds the icing to the cake.

28–70mm lens at 28mm, f/8 for 1/125 sec., ISO 100, Aperture Priority mode, Photoshop Diffused Glow

Every now and then, when doing fashion photography, you just want to break the rules of composition. Bambi simply asked for a surprised look, and this is what the subject came up with. (This subject was a model needing images for her portfolio.) Throw in some cross processing and the result is anything but traditional.

70–200mm lens at 150mm, f/2.8 for 1/60 sec., ISO 100, Aperture Priority mode, Kevin Kubota Photoshop Action Cross-Processed

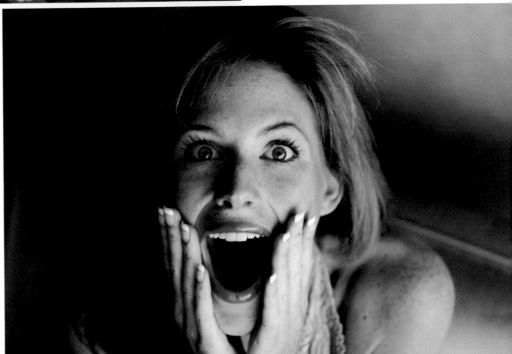

anytime, anywhere

As a professional photographer, you should be able to create high-impact images absolutely anywhere (regardless of subject gender or age). Take a close look at the following photographs. They were all created in a hotel bathroom and simply prove the point that it's about light, expression, posing, and camera angle.

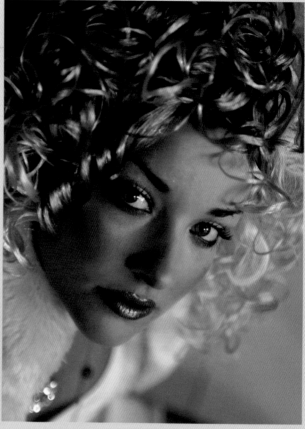

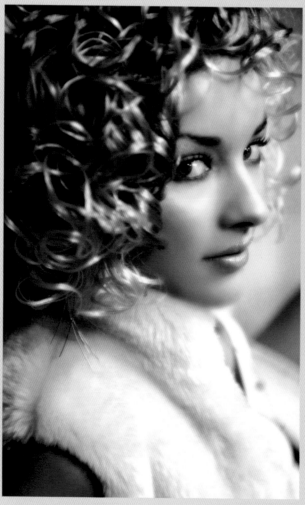

Notice the bends in the joints in the photo opposite; the hips are shifted away from the camera, and the face is turned up toward the light source, which was just a ceiling spotter. Each digital filter or plug-in has its own personality. For example, the Proofz plug-in, used at left, results in a very clean, pretty look. If you experiment with a variety of filters, you can determine which effects you like best.

LEFT: 85mm lens, f/2.0 for 1/30 sec., ISO 400, Aperture Priority mode, Proofz Photoshop Action Black and White; ABOVE: 85mm lens, f/2.0 for 1/30 sec., ISO 400, Aperture Priority mode; OPPOSITE: 28–70mm lens at 28mm, f/2.8 for 1/15 sec., Aperture Priority mode, Kevin Kubota Photoshop Action Black and White

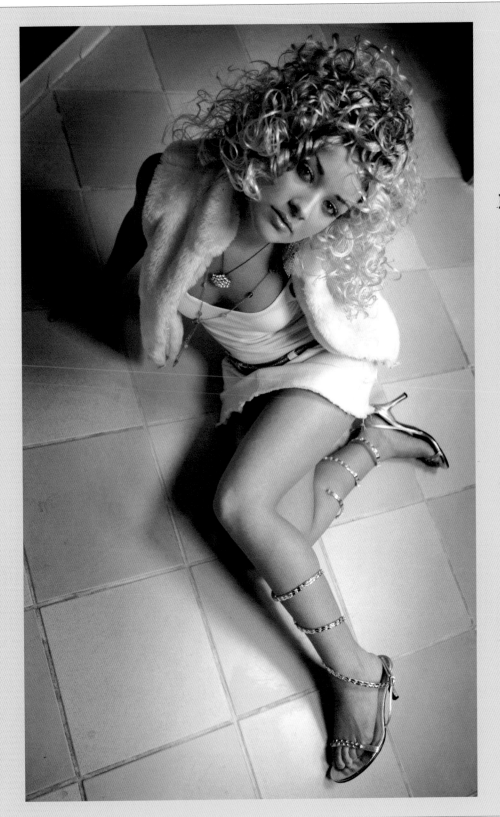

Not every photo session is going to give you the opportunity to bring in a high-fashion look. Sometimes, just the expression and the simplicity of the image make the photo a winner.

props

One of the fun aspects of photographing women is the ability to add a few props and to simply get funky. Sure, you can use props with male subjects, but there's simply more to work with when it comes to photographing women. We've got only one primary tip: Nothing is impossible.

When it comes to adding a few props to your repertoire, just about anything goes. Bambi tends to like things with texture: fabric, hats, and always jewelry. Then, there are the unexpected props, like an old iron gate or a window frame found at a junkyard.

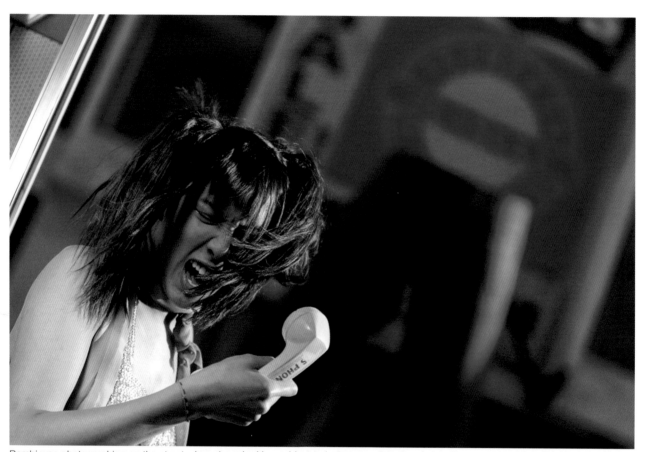

Bambi was photographing on the street when she asked her subject to just scream into the phone. The results were perfect and fit with the personality of an energetic teenager.

70–200mm lens at 140mm, f/2.8 for 1/250 sec., ISO 100, Aperture Priority mode

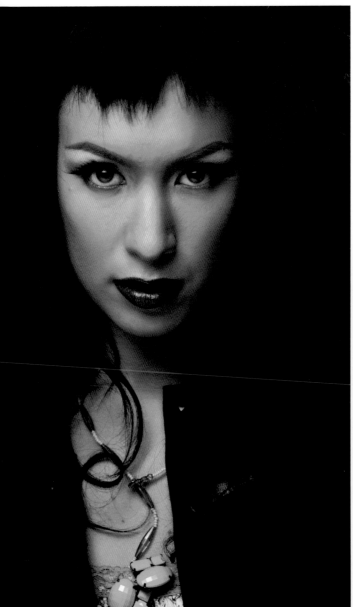

Using a large, directional light source (in this case, coming from the left) gives the prop—the interesting necklace—added texture and shape.

28–70mm lens at 50mm, 1/125 sec. at f/5.6, ISO 100, Manual mode, fill light at f/4

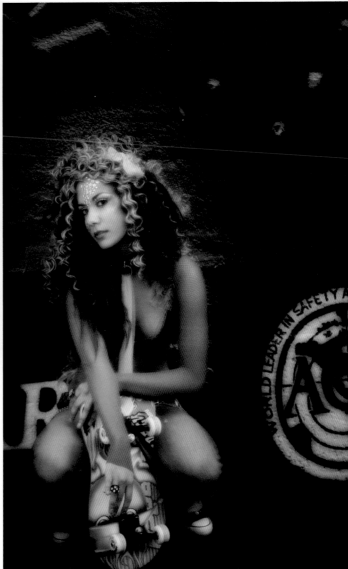

This model's favorite hobby was skateboarding, which provided the perfect prop to help capture the subject's personality.

70–200mm lens at 200mm, f/2.8 for 1/125 sec., ISO 100, Aperture Priority mode, Nik Midnight, increased contrast by 30%

attitude and light

OFTEN, PORTRAITS ARE simply about attitude. There's nothing wrong with mystery in an image; you don't need the full head shot when the eyes say it all. A pose that has the figure leaning against a wall, together with a bit of camera tilt, gives the subject a little more bulk and a little more sex appeal—relaxed but still in command.

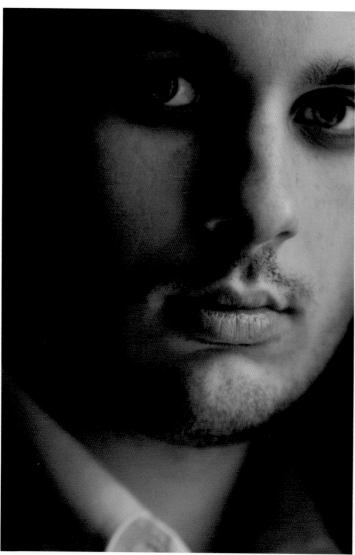

In both these images, the main light is coming from the right side of the image. It provides a beautiful shadow on the other side and gives the subject's face more shape.

ABOVE: 70–200mm lens at 200mm, f/2.8 for 1/15 sec., ISO 400, Aperture Priority mode; RIGHT: 70–200mm lens at 200mm, f/2.8 for 1/60 sec., ISO 100, Aperture Priority mode

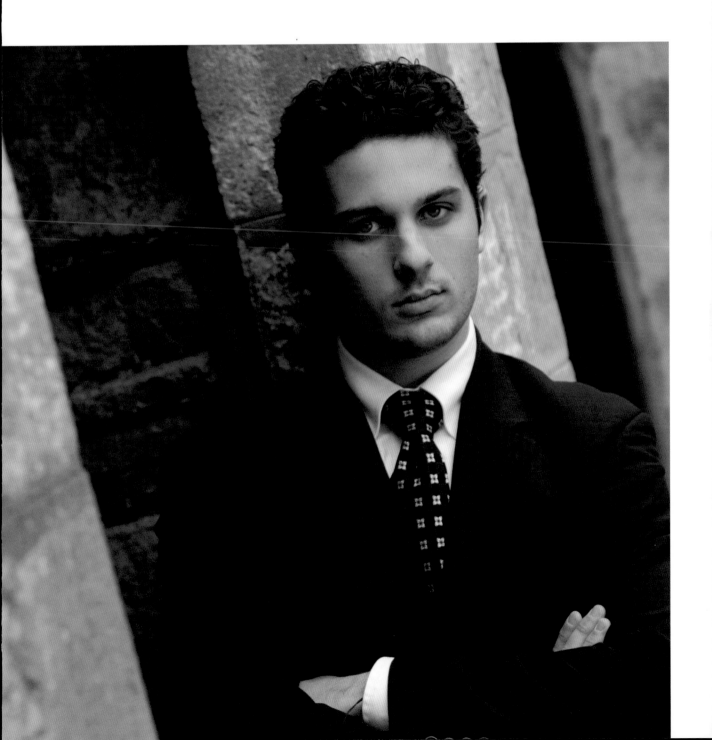

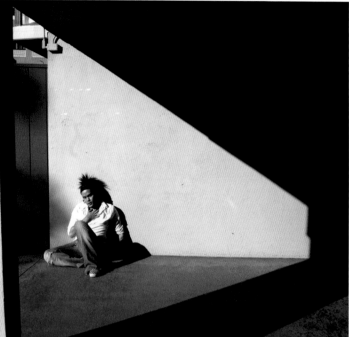

ABOVE: Notice the impact the shadow on the wall has on the overall feel of the portrait. It adds drama to the final image. In addition, black and white is a must with a shot like this, adding more mood and mystery.

28–70mm lens at 28mm, *f*/2.8 for 1/25 sec., ISO 100, Aperture Priority mode, Kevin Kubota Photoshop Action Black and White

RIGHT: If you know the rules, then you can break them. Here, Bambi photographed looking slightly down on the subject. The subject looks anything but squat and is loaded with attitude, but there are two other things going on. First, having the subject tilt his chin down makes the eyes look larger. Second, showing off a little of the subject's chest by opening his collar adds a little masculine sex appeal to the shot. And note that it's all in keeping with the purpose of the photograph: The subject is a model and needed to build his portfolio.

Also, take a look at the light. If the light is good, you can photograph anywhere. That's just a plain concrete wall in the background, with a single reflector popping in natural light. Now add a shallow depth of field, and all the ingredients work to create an image that screams *mystery*.

70–200mm lens at 160mm, *f*/2.8 for 1/60 sec., ISO 100, Aperture Priority mode, Proofz Photoshop Action Infrared #1

the direction of the light

Notice the direction of the light in the image above. It's coming from the left at a 45-degree angle to the subject's face. This is *short lighting* at its best. Taking advantage of this kind of lighting gives the face stronger, more defined dimensionality. To achieve this effect, look for a setting with the light coming from the direction you want. You can also manipulate the light with the use of a reflector.

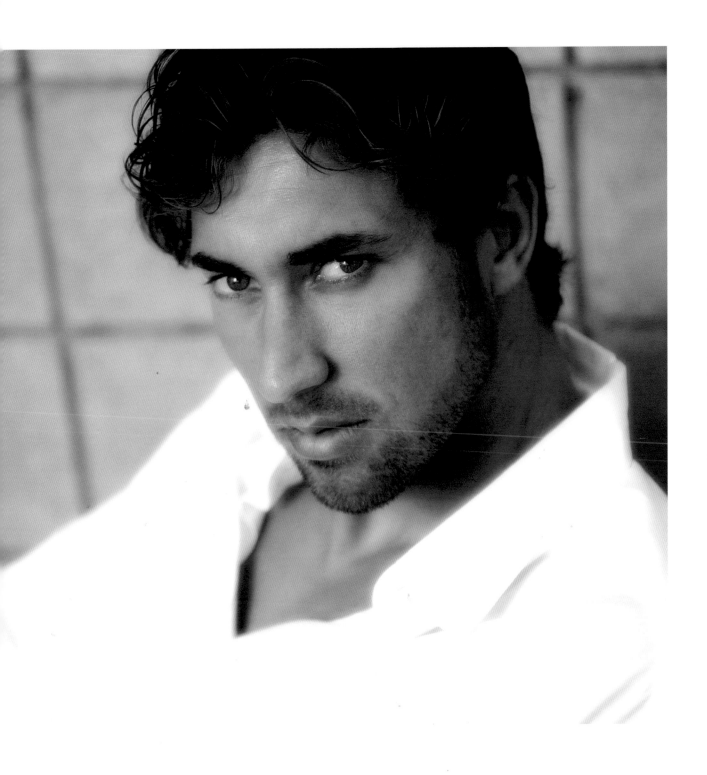

groups

WHILE COMPLETELY DIFFERENT from one another, these images of a group of three musicians were all made at the same location during the same sitting. If you compare them, you'll see that a lower camera angle adds more impact to a small-group portrait. In this case, the three musicians appear more in charge.

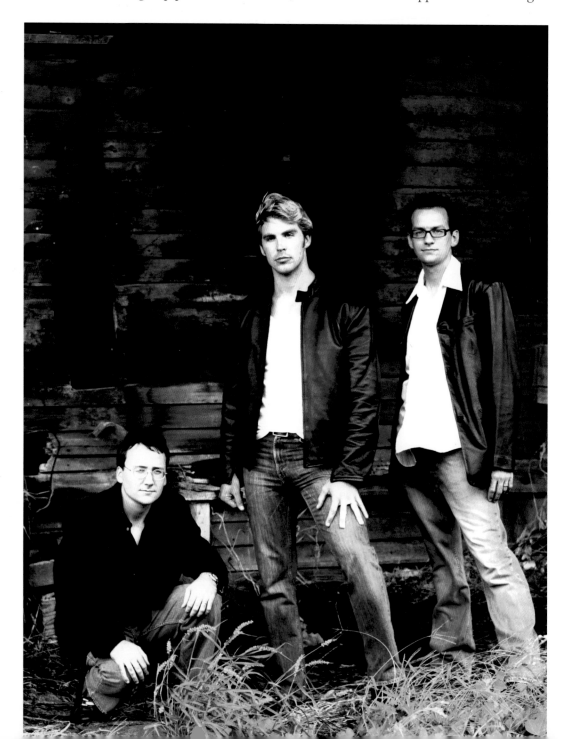

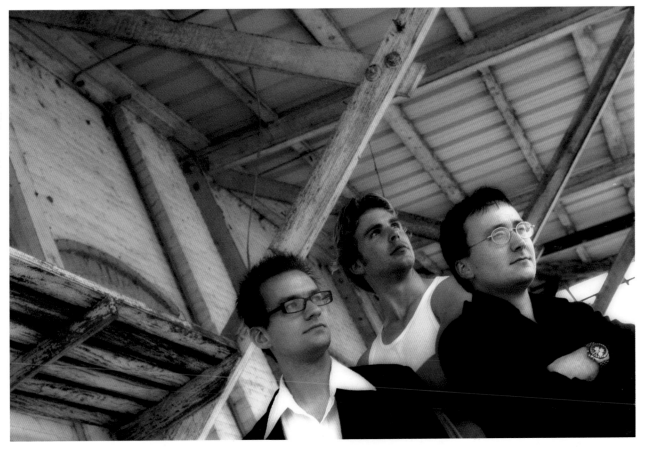

breaking out a detail from the group

Don't be afraid to use components of one portrait to create another—or to break out a single-subject portrait from a group shot. Bambi created this black-and-white head shot by simply zooming in on one subject during the group session shown here.

Both the image opposite and the one above were altered digitally to get different results. The shot opposite is the result of increased contrast (done in Photoshop). The shot above was manipulated using a Nik Software plug-in for Photoshop.

OPPOSITE: 28–70mm lens at 28mm, f/5.6 for 1/125 sec., ISO 100, Aperture Priority mode, increased contrast by 45%; ABOVE: 70–200mm lens at 200mm, f/2.8 for 1/60 sec., ISO 100, Aperture Priority mode, Nik Duplex

color vs. black and white

LET'S START WITH the first issue or rule of creating black-and-white images: Capture everything in color—i.e., work in color—that way, you maximize your options with the final photograph. While we're huge fans of black-and-white photography, you still need to understand how to create in both color and black and white.

Truthfully, there are no other steadfast rules; it's about personal taste and your client. Personally, we feel that black and white removes any distractions from an image and simply focuses in on the subject. (It's especially effective with tighter head shots.) But, be prepared to offer a selection of both formats to your client. One added benefit of black and white is simply that light is light—it can transform the ugliest locations in the world into works of art when you convert a color shot to black and white!

What better example to use to make this comparison than these two images of Bambi herself. James Fidelibus was the photographer, and all of us agree that his shot is the best business portrait Bambi has had in years, but the image has a totally different feel in color than it does in black and white. Photographed originally in color, the images was converted to black and white in seconds, in this case using Nik's Black and White filter plug-in. Also, notice the successful use of a high camera angle and flat light.

RIGHT: 70–200mm lens at 150mm, f/2.8 for 1/30 sec., ISO 100, Aperture Priority mode; OPPOSITE: converted with Nik Black and White

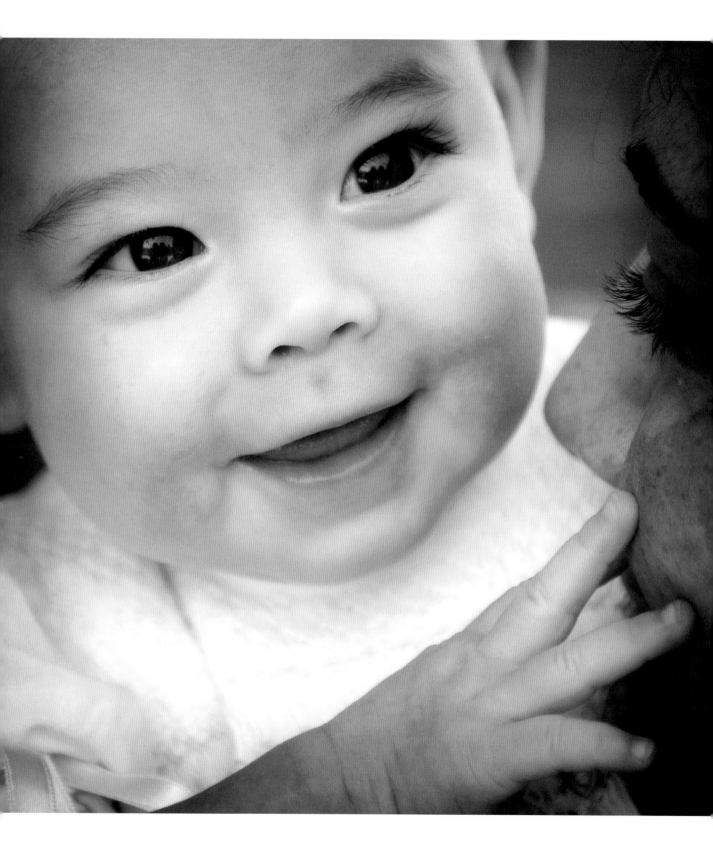

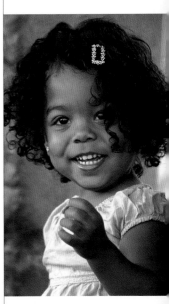

babies & children

Newborns become infants

and infants become children, and most photographers approach photographing any of the three with all the enthusiasm of paying their taxes! Yes, there are those few brave souls who are gifted and truly love to photograph kids of all ages, shapes, and sizes, but for the majority of the world, it's too often an adventure into the unknown. But with a little preparation, it doesn't have to be this way.

newborns

Treat photographing each newborn with the same enthusiasm you'd bring to photographing your own child.

LET'S START AT the very beginning, with newborns. Keep in mind my earlier analogy: You're really a sculptor working with raw clay. You've got a baby, who has absolutely no idea what's going on, and two new parents. If this is their first child, the parents likely aren't any more adept than the baby at a photo shoot. Everyone is confused and a little apprehensive—which means there's no room for you, as the photographer, to add your own hesitancy to the mix. You have to go into the session with confidence.

First, assemble all the tools you're going to need, and decide on the location. Are you shooting in the home, the studio, or for that matter at the hospital? It's especially important to use a quiet location. Don't underestimate the importance of a few toys. In the case of newborns, that really means a few distracting props. (See box on page 73.)

Second, allow plenty of time. This way, even if the baby is fussy, you can relax because you've left room in your schedule to get the images. The only predictable thing about working with babies is that they're unpredictable. If the baby is fussing or crying, it's going to take a quiet atmosphere with soothing tones or squeaky sounds—things that distract babies and awaken their curiosity—to capture the best images.

If you're a little reserved and think interacting with the parents and baby isn't in your repertoire, you'll be finished before you get your first shot. You've got to just relax, overcome your hesitancy, and treat photographing each newborn baby with the same enthusiasm you'd feel for photographing your own newborn child.

Our first preference is always working with natural light, and you want it all on the face. For obvious reasons, try to stay away from flash photography if you can help it. Also, you're going to be looking for nice tight shots with a narrow depth of field. The lenses of choice are the 85mm, 28–70mm, and 70–200mm IS zoom. The advantage of the zoom is in its ability to compress the background, allowing you to concentrate on the face and expressions of the subject without distractions.

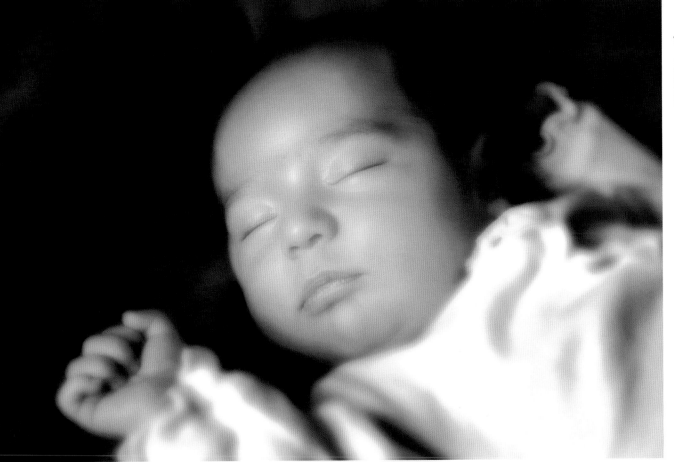

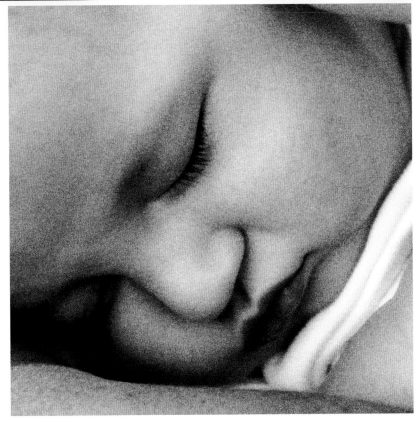

Bambi has found the following to be a nice sequence for photographing newborns: sleeping; awake with mom, dad, or both; and then by themselves. If the baby arrives at the studio asleep, or you arrive at the parents' home and the baby is asleep, don't worry about it. Sleeping babies are the ideal start.

The composition above is probably the more typical of the two shown here, but notice the impact of the second one, left, when Bambi zooms in to capture just the baby's face.

ABOVE: 28–70mm lens at 70mm, f/2.8 for 1/15 sec., ISO 100, Aperture Priority mode, Kevin Kubota Photoshop Action Sepia; LEFT: 70–200mm lens at 200mm, f/2.8 for 1/15 sec., ISO 100, Aperture Priority mode, Kevin Kubota Photoshop Action Grainy Film

when the baby is awake

Look for the interaction between the mother or father (or both parents) and the child. Try to function just as an observer, and let them interact. Using the zoom, you'll be able to isolate the baby from the background. This is also where those props you brought along come in handy as your goal becomes to get the child to look right down the barrel of your lens.

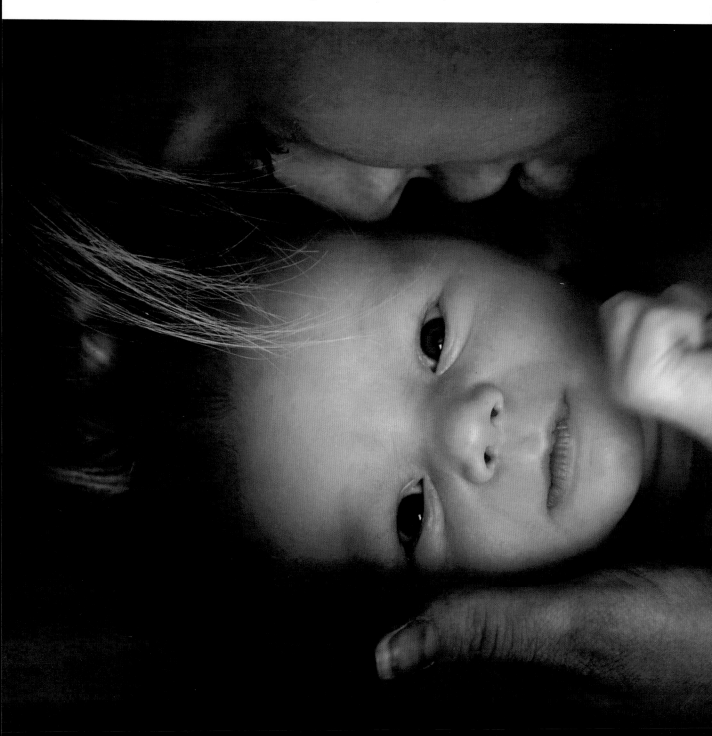

newborn toolbox

- Canon EOS 1D Mark II
- 70–200mm IS lens
- 28–70mm lens
- Beanbag
- Studio lighting, if needed. (While natural lighting is always preferable, there are days when window light just isn't up to par—rainy days, for example—and the quality of natural light isn't there. In those cases, the lighting setup for newborns would be pretty much the same as with any subject. It's just good to have as a backup if the natural light is less than ideal.)
- Radio slaves
- Props (toys, twinkling lights, feather dusters, even cat toys that squeak)

You'd never know the baby was screaming seconds before Bambi took this shot. The baby was cranky, but when the mother put the baby on the floor and started to interact to calm the baby down, we had, at best, thirty seconds to get the shot. Henri Cartier-Bresson's Decisive Moment can happen at any time with any photograph. Or, to be a little more contemporary, when shooting newborns, *be prepared*— you snooze, you lose.

70–200mm lens at 135mm, f/2.8 for 1/60 sec., ISO 200, Aperture Priority mode

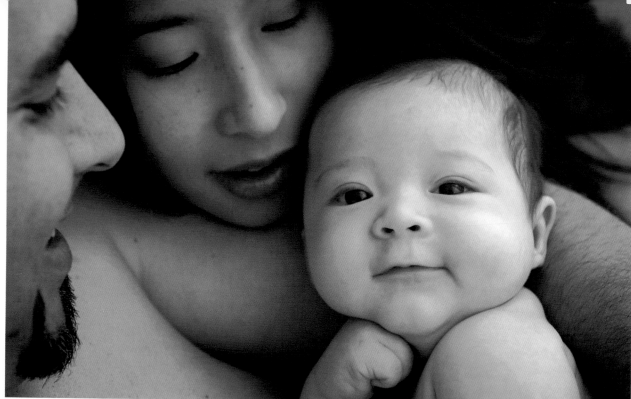

The purpose of the portrait is to capture the face, so stay away from clothes and patterns that are distracting. Think *monochromatic*, and avoid bold colors and patterns. Remember: Focus on the face.

ABOVE: 28–70mm lens at 70mm, f/3.5 for 1/60 sec., ISO 400, Aperture Priority mode, Proofz Photoshop Action Black and White; RIGHT: 28–70mm lens at 70mm, f/3.5 for 1/60 sec., ISO 400, Aperture Priority mode, Proofz Photoshop Action Black and White

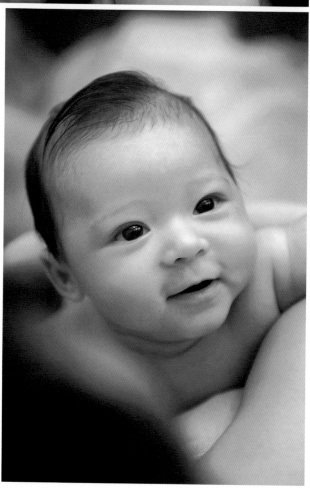

a few easy tips

- Work fast!

- Work with an assistant, if possible—it helps to have somebody assist you in drawing the baby's attention to the camera.

- Go for tight close-ups. Don't pull back too far— this is all about the baby. The baby is tiny compared to the parents, and you don't want to lose the baby in a family portrait.

- Don't worry about how many images you're taking.

- Plan for the unexpected (anything from a cranky baby to a diaper that needs changing).

- Work in short segments, and don't drag out the session.

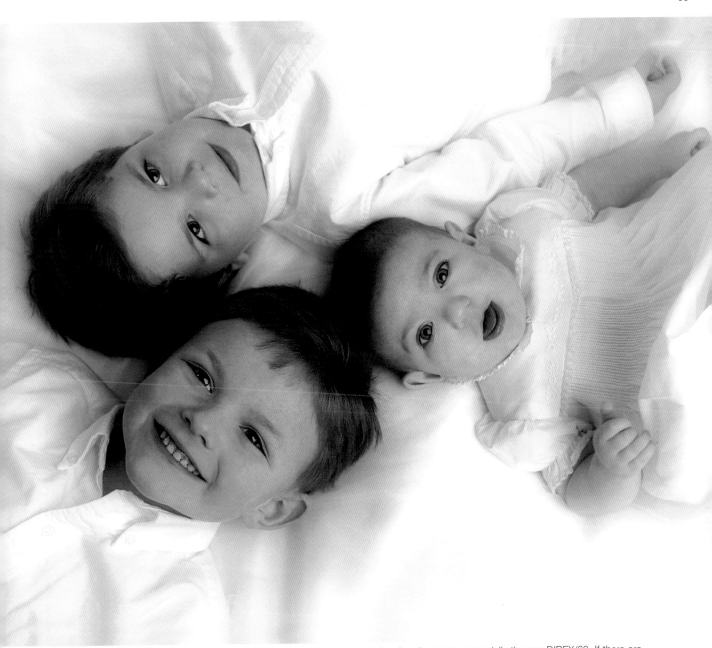

The last thing we want to suggest is posing cards, but Bambi does have a few favorite poses, especially the one DIREX/69. If there are other children in the family, don't forget the siblings. The session may be about the new baby in the family, but the key word here is *family*. You're looking for ways to draw out interactions among *all* the family members. Bambi has also found that putting kids on their backs restricts their movement just enough to get their attention and to give her what she needs in terms of keeping the focus on the faces of the subjects. Kids seem to like this pose as well—it's different, it's fun, and it doesn't put an excessive amount of attention on the new baby. Everyone in the shot feels special.

A note about the light: While Bambi likes to stay away from flash photography, there are some easy ways to bring in artificial light and not detract from the image. To create this image, Bambi used a large softbox over her subjects' heads, so the faces were flat-lit.

28–70mm lens at 35mm, 1/60 sec. at f/5.6, ISO 100, Manual mode, one softbox

baby body parts

WHEN DON BLAIR WROTE his portrait book, *Body Parts*, it was all about what to do with the challenges in adult portraiture, but when you're working with babies, individual body parts become a critical component of a photo session. There's nothing cuter than baby hands, feet, eyes, noses—all those components that parents focus on as they proclaim, "Look! He's got my eyes!"

Body parts make the perfect subject matter with which to occupy your time during a diaper change, a cranky period, or just downtime. Again, it's about using the right lens, and looking for compressed backgrounds and a narrow depth of field, allowing you to isolate the part you're trying to photograph.

Body-part images can make an incredible sequence of shots. They can become a triptych, for example, of the newborn and can eventually be sold either as a group or as individual components. These three photographs were taken by one of our favorite children's photographers, Michael Van Auken. The only thing more impressive than his photographic skills is his ability to anticipate a child's reaction.

RIGHT: 70–200mm lens at 200mm, f/2.8 for 1/30 sec., ISO 400, Aperture Priority mode, Kevin Kubota Photoshop Action Black and White; OPPOSITE TOP: 70–200mm lens at 200mm, f/2.8 for 1/30 sec., ISO 400, Aperture Priority mode, Kevin Kubota Photoshop Action Black and White; OPPOSITE BOTTOM: 70–200mm lens at 200mm, f/2.8 for 1/30 sec., ISO 400, Aperture Priority mode, Kevin Kubota Photoshop Action Black and White
Photos © Michael Van Auken

when babies become kids

IN ORDER TO CAPTURE the best images of a child, you've got to bring yourself down to the child's level, literally. It's all about getting the child to interact, whether it's with the parents or with you, the photographer. It may seem silly, but get down on the floor before the session and check out the environment. Whether you're in your studio or the child's home, double-check for anything from a paper clip to a lamp cord—anything that might distract or potentially harm the child (or be a distraction in the composition). This is also the perfect time to check out the perspective from the child's angle of view.

Every image you capture is a reflection of the trust you've established with the client— or with both the client and the subject, if they're not one and the same.

BELOW: 70–200mm lens at 165mm, f/2.8 for 1/200 sec., ISO 125, Aperture Priority mode

OPPOSITE: 28–70mm lens at 70mm, f/2.8 for 1/60 sec., ISO 100, Aperture Priority mode, Proofz Photoshop Action Black and White

a note about aperture

Larger apertures are always Bambi's preference, especially with single-subject images. She wants the depth of field as shallow as possible, allowing her to isolate specific attributes of the subject.

To make the shot,
you've got to bring
yourself down to
the child's level,
literally.

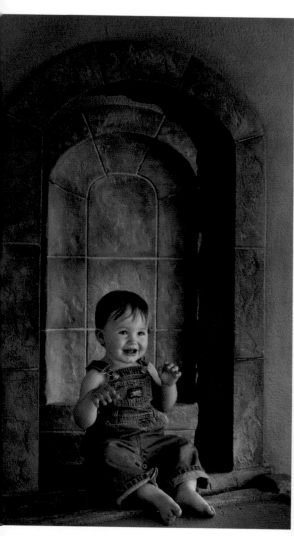

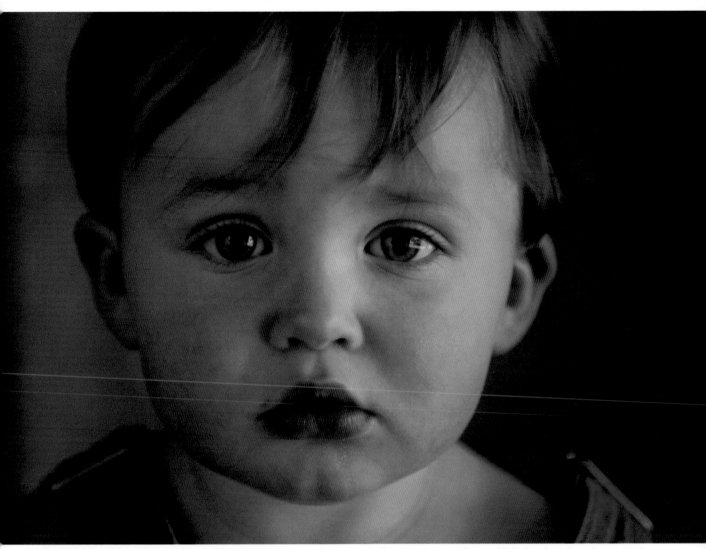

Bambi captured all of these images within minutes of one another in the studio. All make use of natural light, but the winner in our—and the parents'—opinion is the tight face shot, which Bambi made by changing lenses, *not* by overcropping the photo in the computer. (At virtually every workshop, Bambi is asked how much manipulation she does of her images. While she loves the creative tools digital technology has provided, she gets the image right in the beginning and *in the camera*. She feels that getting it right in the first place is what being a professional is all about.)

The best thing about a tight face shot is that you can get it anywhere. You can photograph in a bathroom as long as the quality of the light is good—light with a direction, not too flat, giving you highlights in the eyes and details in the shadows. You don't want the light to come from below or too high above.

OPPOSITE LEFT: 28–70mm lens at 28mm, *f*/4.5 for 1/125 sec., ISO 400, Aperture Priority mode; OPPOSITE RIGHT: 28–70mm lens at 28mm, *f*/4.5 for 1/125 sec., ISO 400, Aperture Priority mode; ABOVE: 70–200mm lens at 200mm, *f*/2.8 for 1/60 sec., ISO 400, Aperture Priority mode

sequences

One of the most wonderful things about photographing kids is the opportunity to capture events in a sequence. Every movement and expression creates a new opportunity for a series of photographs. And, don't be afraid to talk to your subjects, especially when they're kids. Ask them questions that engage their interest and get them talking about topics they enjoy.

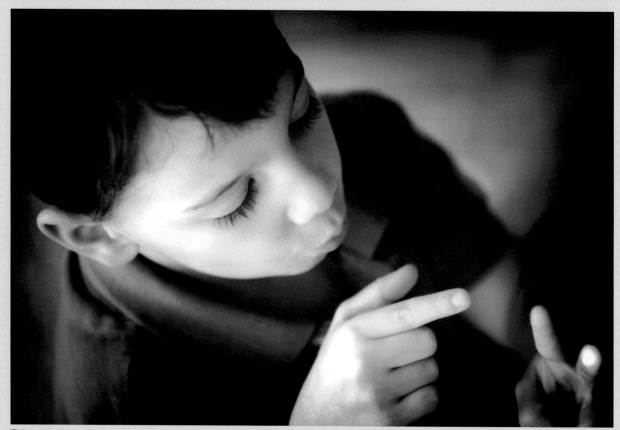

This particular series captures the answer to the photographer's question, "Zachary, how old are you?" You can follow the complete thought process of counting and demonstrating how old he is with just three fingers. The tight head shot, the high camera angle, the black-and-white format (rather than color), the shallow depth of field, and the interaction with the photographer are all key ingredients that go into creating these portraits.

ALL PHOTOS: 70–200mm lens at 200mm, f/2.8 for 1/60 sec., ISO 100, Aperture Priority mode, Nik Black and White

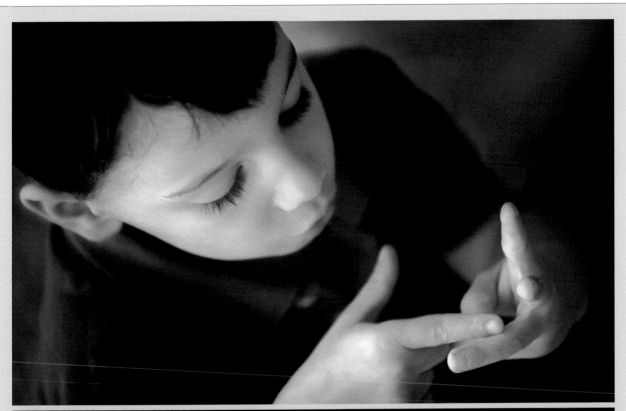

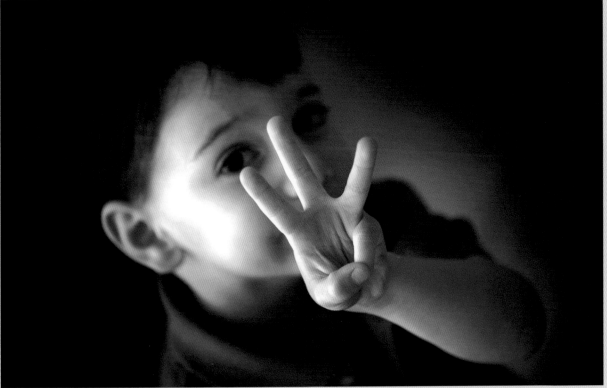

kids and color vs. black and white

LET'S TOSS IN one new variable: color vs. black and white. As with adult subjects, beauty is in the eye of the beholder, so you be the judge. From our perspective, the black-and-white image simply has more power. It's not just because we're fans of black and white; it's because this portrayal shows emotion without distraction. It's about capturing the essence of the child and not caring about the colors in the image.

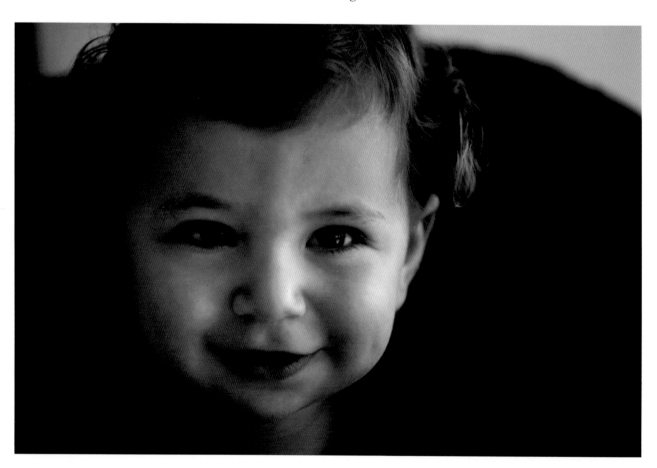

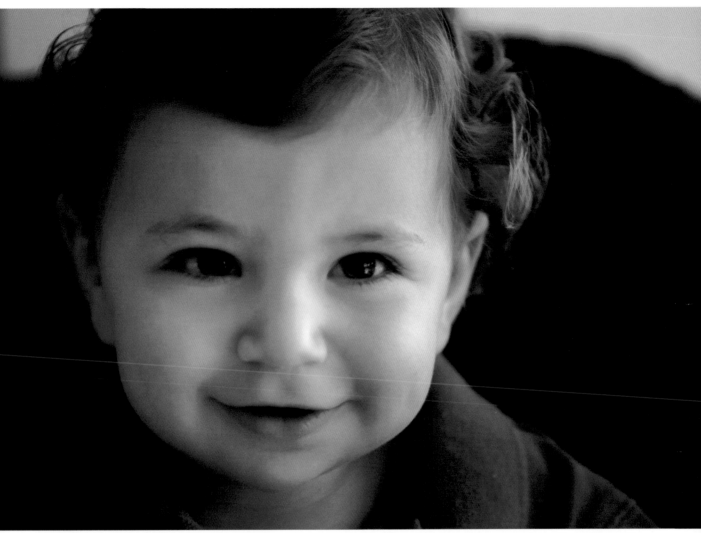

This is one of my favorite images that Bambi has taken of my grandson Luke. The setting was our living room floor with sidelight coming in from the back porch. I love the look on Luke's face and the pure joy as we caught him just before a chuckle—you don't need a big toothy grin to create a killer image!

While we prefer the purity of black and white, color can also have its pluses. Color can add warmth to images and make them inviting. Opposite, the redness of Luke's mouth is echoed nicely in his shirt. Also, the light can sometimes look less flat, and elements can pop more in color (as Luke's eyes do here). As we mentioned before with adult subjects, don't just fall into the habit of shooting in black and white with kids. You may miss some beautiful shots. If you've shot in color, you'll have the flexibility later to make the decision as to which format is more successful on a case-by-case basis.

70–200mm lens at 200mm, f/2.8 for 1/60 sec., ISO 100, Aperture Priority mode, converted with Kevin Kubota Photoshop Action Black and White

scale

THERE ARE TIMES when bringing a parent into the shot simply helps give perspective on a child's size. If mom and dad aren't available, you can always take advantage of furniture to add a sense of scale.

When you're doing a portrait session on location, be prepared for the unexpected. For example, sometimes kids just don't want to cooperate and wear clothes. Bambi made the image above when she arrived early to a shoot and the parents were still trying to dress their daughter.

ABOVE: 70–200mm lens at 200mm, f/2.8 for 1/15 sec., ISO 400, Aperture Priority mode, Kevin Kubota Photoshop Action Black and White

OPPOSITE: 70–200mm lens at 200mm, f/2.8 for 1/125 sec., ISO 100, Aperture Priority mode
Photo © Michael Van Auken

kids and studio vs. location

THERE ARE OBVIOUS advantages to both studio and location photography. In the studio, as the photographer, you have more control. However, on location you're really able to be in the child's environment, and your interaction with the child becomes more dynamic.

Bambi prefers photographing on location, simply because she has more freedom and room to move in the subject's environment, especially with children. There's more variety and more to work with in a child's natural space. Plus, there's a bonus: Children will always be more relaxed in their own environment. Of course, this is all about personal choice as a photographer. There are plenty of outstanding photographers who prefer the control they have in the studio.

Whether you're on location or in the studio, make sure the direction of the light is clearly defined.

LEFT: 28–70mm lens at 50mm, f/2.8 for 1/125 sec., Aperture Priority mode

OPPOSITE: 70–200mm lens at 200mm, f/2.8 for 1/60 sec., ISO 100, Aperture Priority mode

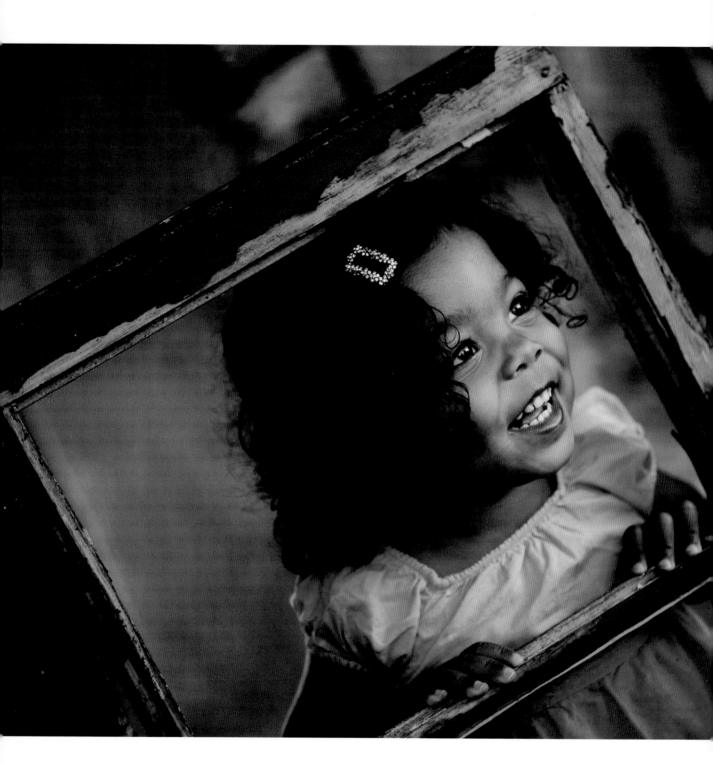

Bambi has a couple of different sets from Off the Wall. They're light and easily stored and moved. While this image was created in the studio, it feels like it was created outdoors—due to the set.

BELOW: 70–200mm lens at 160mm, f/2.8 for 1/60 sec., ISO 100, Aperture Priority mode, Proofz Photoshop Action Black and White, handcolored; LEFT: 70–200mm lens at 200mm, f/2.8 for 1/60 sec., ISO 100, Aperture Priority mode, Kevin Kubota Photoshop Action Cross-Processed

sets

For studio photography, you don't have to have a gigantic studio to have a few key components for creating outstanding images (for example, backdrops and sets). Off the Wall is our favorite manufacturer of composite-material sets. Each set has two sides, and the versatility is unlimited; you can even use the sets to display images in a studio window when you're not using them for a portrait session.

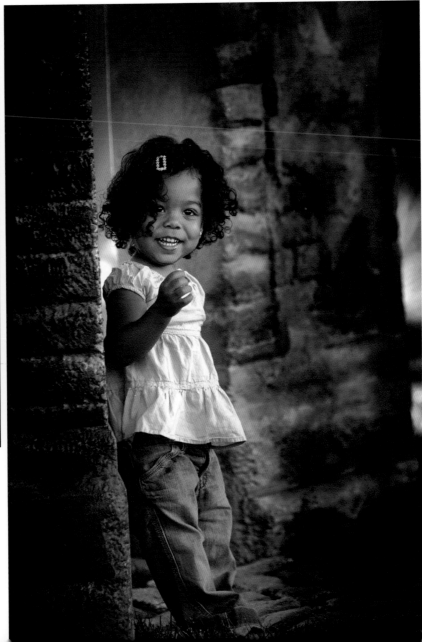

breaking the rules

YOU HAVE TO KNOW the rules of composition before you can break them, but once you have those guidelines under your belt, don't be afraid to completely ignore them. Let's start with the old Rule of Thirds. You need to understand when it works to divide your frame in thirds horizontally and vertically to find the best off-center subject placement, and when "expression beats perfection"—when you may not compose things perfectly but the expression is so outstanding that you can't miss the moment. The same would hold true for the old rule of not cutting off the top of the head or any part of the face. And, this concept doesn't just apply to the rules of composition, but to all the other important elements of photography, from depth of field to exposure. No level of technology is going to replace the importance of understanding these photographic basics—and then knowing when you can ignore them.

Also, keep in mind that with children, even more so than with adults, the portrait is about the *emotion*. If a composition breaks a rule but is still successful on emotional (or other) levels, ignore the rule.

Bambi chose to break the rules and center her subject here because that's what got her the photo with the most impact (regardless of what the rules dictate).

70–200mm lens at 200mm, f/2.8 for 1/60 sec., ISO 100, Aperture Priority mode, Kevin Kubota Photoshop Action Black and White

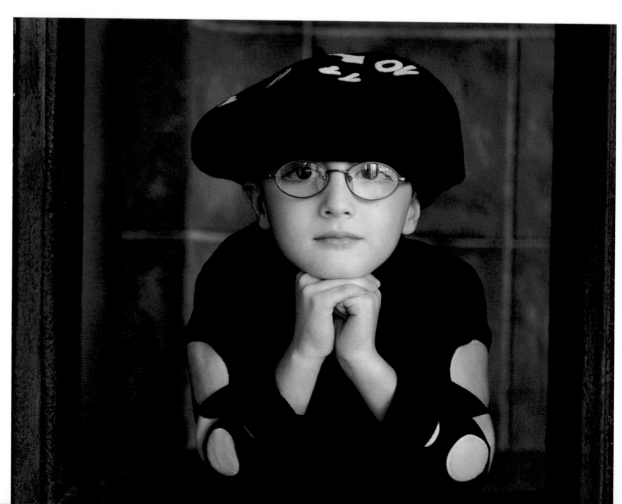

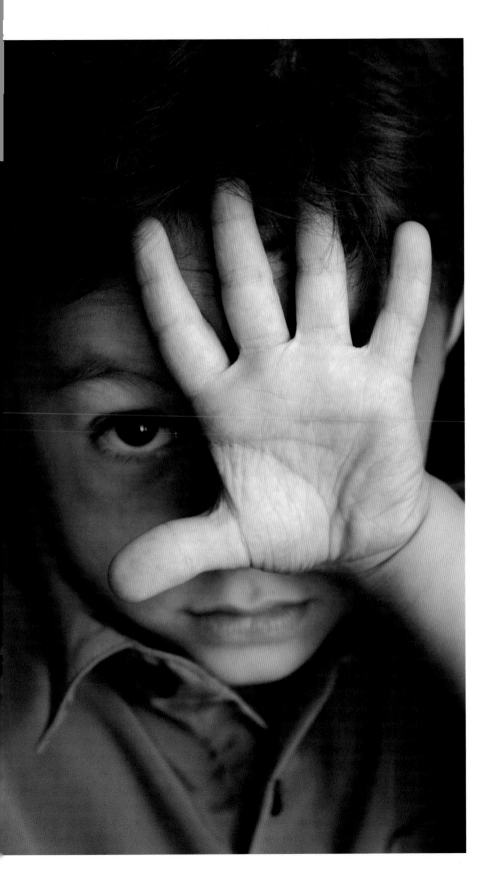

Bambi's epiphany

Bambi's ability to photograph children came out of her own lesson as a mother photographing her son, Cameron, years ago in the studio. "Cameron, you sit still and smile, or you're going to get a time out!" The result was obvious; he cried and she felt incredibly guilty, having let her own frustrations erupt to the surface and ruin the session.

The lesson learned: With children, "you have to bring yourself to their level. My camera becomes secondary to my voice, my enthusiasm, and the interaction I want to have with the kids. The minute I connect, my camera's ready to grab the shot— and it just keeps getting better as the session and the interaction with the child continue."

This subject was incredibly shy, and when asked his age, he answered by holding up five fingers, partially obscuring his face. Even though this gesture breaks the traditional rule of not blocking the subject's face, it also successfully communicates information about the subject—and it speaks volumes about capturing the image rather than trying to create it. Listen with your eyes!

28–70mm lens at 70mm, 1/60 sec. at f/2.8, ISO 100, Kevin Kubota Photoshop Action Black and White

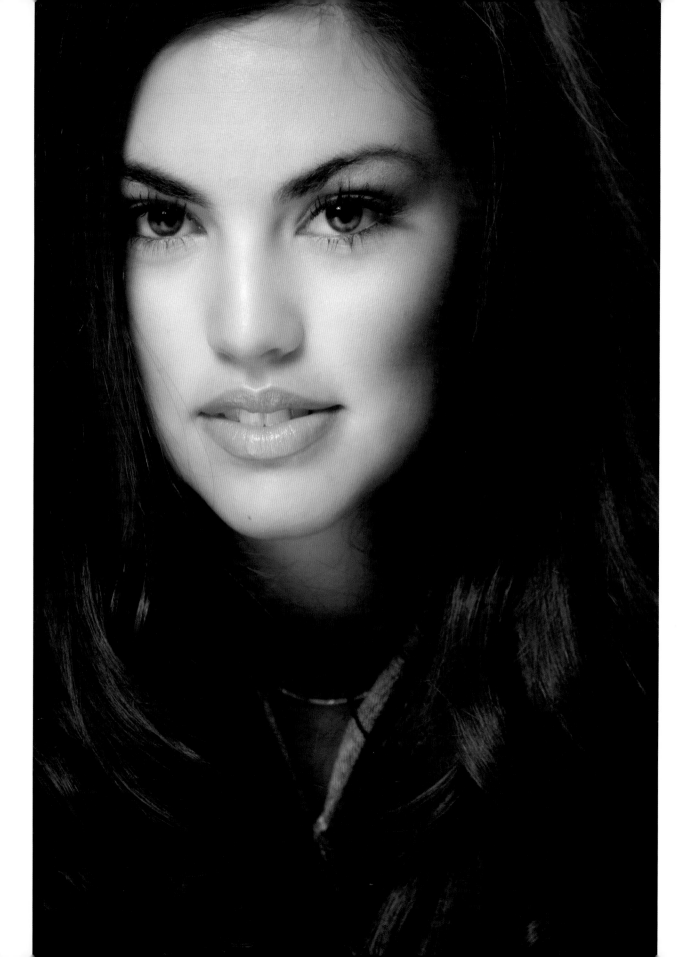

high school seniors

For most high school seniors, a formal portrait session will be their first experience with a professional photographer for which they (in addition to mom and dad, who are paying the bill) are the client. Keep that in mind as you reflect on what you were like as a senior. Also, remember that your ability to develop a relationship with your "senior clients" is an investment in your future. High school seniors become brides and grooms. Brides and grooms become parents, and throughout this cycle, there will be events to record that require the skills of a professional photographer.

know your subject

WHAT WAS YOUR SENIOR YEAR in high school like? Since the most critical component in making a great senior portrait is your ability (as the photographer) to get to know the subject, think back. Your complexion was probably lousy. Every day brought about a new insecurity. You felt like an adult and were old enough to drive and take responsibility for your younger siblings, but you weren't allowed to make all of your own decisions. You had an incredible loyalty to your friends, and your hobbies were your life, not just something you did to relax. Last but not least, you were chomping at the bit to be on your own, and those days of more independence, along with graduation, were just months away. In comes the professional photographer and the school, along with mom and dad, wanting your senior portrait done!

28–70mm lens at 50mm, f/2.8 for 1/30 sec., ISO 400, Aperture Priority mode

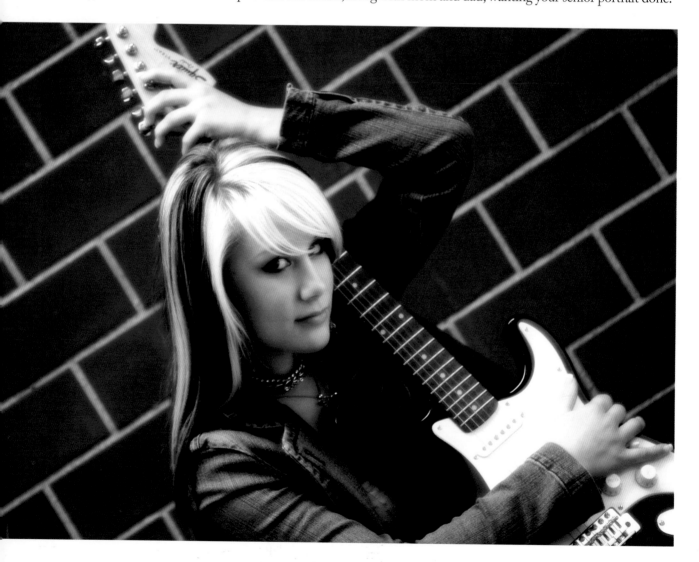

Once you remember what that time in your life was like, the first thing to do is meet with your high school senior subjects. Find out where they shop and how they want their senior portrait to look. Next, find out something about their interests, and let them talk about what they want to wear in their portrait session. Are there props—for example, musical instruments, sports equipment, even a dirt bike—they'd like to include in the image? Don't forget to ask about their pets. They need to know that nothing is outside the realm of possibilities for their photography session. This opens the floodgates to reveal who they are and almost immediately creates an unstoppable enthusiasm about their senior portrait.

28–70mm lens at 50mm, f/2.8 for 1/60 sec., ISO 100, Aperture Priority mode

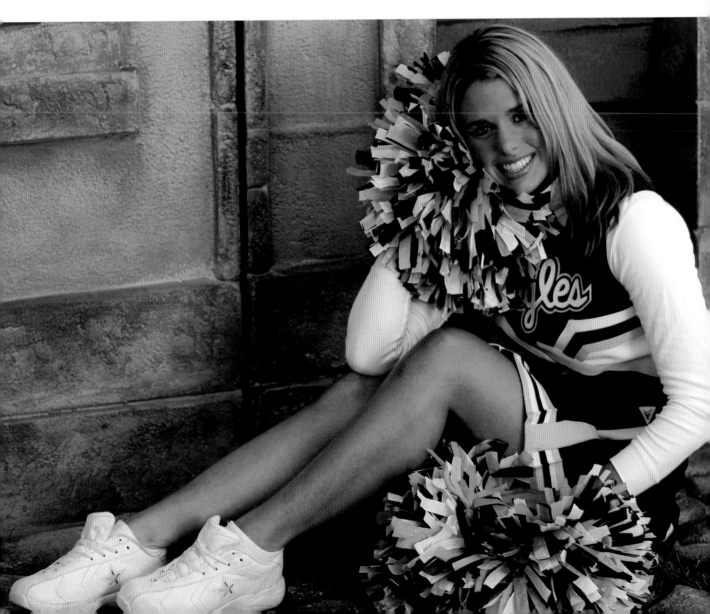

at the photo session

There are certain shots Bambi likes to start with. She will typically begin with straightforward "Hi, Mom" head shots. Throughout this part of the portrait session, she'll constantly talk with the senior, getting to know more about him or her as things progress. This understanding of the subject is critical to being able to create the next set of more contemporary images. It also doesn't hurt to get the basics out of the way—sort of like eating your vegetables as a kid so that you could enjoy dessert. After that, she never charges for a change of clothes or a set change. She considers all of the shots done on that day as one sitting, regardless of how many changes are made to capture the ultimate image.

Once the session gets rolling, you'll be amazed at the expressions you'll be able to capture. Often, since you've established trust with your subjects, you can create the images they want before you start on mom's wish list or on the mandatory shot for the yearbook.

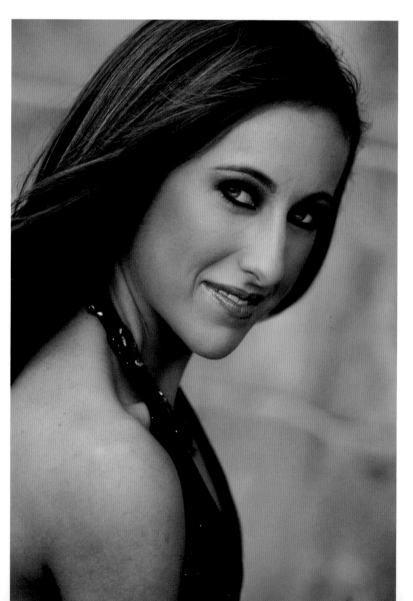

And finally, as you're capturing the images, remember that what you're getting on camera is only a fraction of the finished photograph. What you'll be doing in the computer after the photo shoot is over and the presentation itself will add even more impact to the final senior portrait. (See chapter 8.)

the eyes

Every possible photographic technique comes into play with senior portraits; from digital manipulation to cross processing (see chapter 8), the sky's the limit. However, one consistent element in every image is the eyes. Whether looking right down the lens barrel or completely away from the camera, the eyes tell the story of your student subject. There's no such thing as a head shot that's too tight if you're after the look in the eyes.

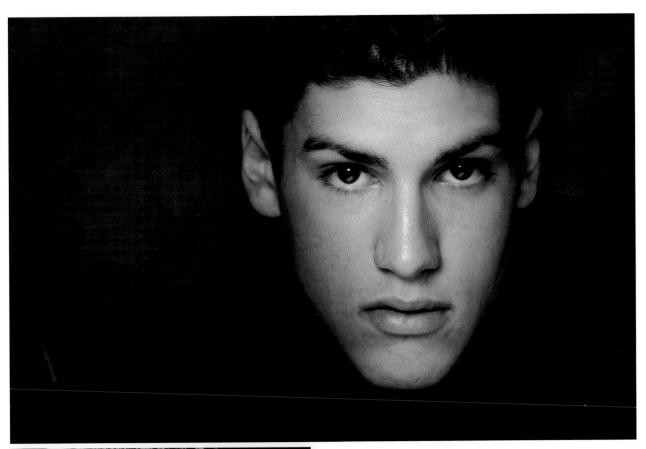

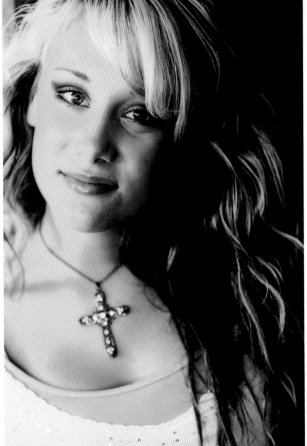

ABOVE: 70–200mm lens at 125mm, 1/250 sec. at f/8, ISO 100, Manual mode

LEFT: 70–200mm lens at 200mm, f/2.8 for 1/125 sec., ISO 100, Aperture Priority mode, Proofz Photoshop Action Infrared #1

OPPOSITE: 70–200mm lens at 200mm, f/2.8 for 1/15 sec., ISO 400, Aperture Priority mode

The most critical part of making a great senior portrait is your ability to get to know your subject.

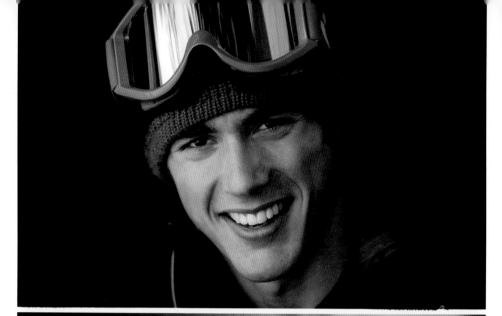

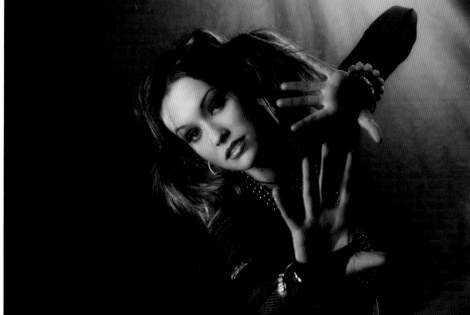

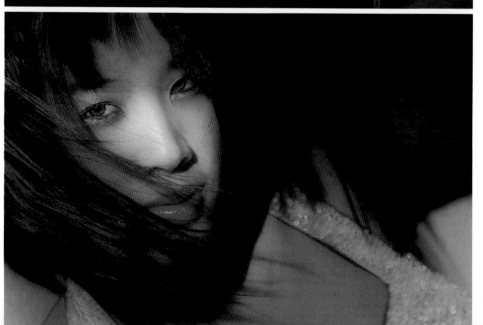

TOP: 70–200mm lens at 200mm, f/2.8 for 1/30 sec., ISO 100, Aperture Priority mode

CENTER: 28–70mm lens at 28mm, f/2.8 for 1/15 sec., ISO 400, Aperture Priority mode

BOTTOM: 70–200mm lens at 200mm, f/2.8 for 1/60 sec., ISO 100, Aperture Priority mode, Nik Saturation to Brightness

make use of the background

As you're concentrating on the eyes, you'll find that you can go back and forth from tighter head shots to more full-length images, taking advantage of the setting you're using to create the image. Pay attention to your background. Backgrounds can enhance an image and add context to your photograph.

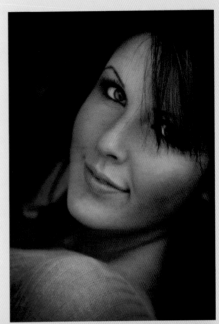

RIGHT: 70–200mm lens at 200mm, f/2.8 for 1/15 sec., ISO 400, Aperture Priority mode

BELOW: 70–200mm lens at 160mm, f/ 2.8 for 1/15 sec., ISO 100, Aperture Priority mode, Nik Midnight

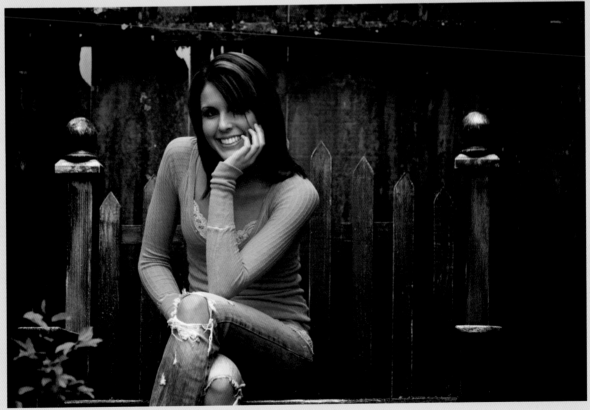

lighting, camera techniques, and props

Bambi made this image with naturally occurring ambient light that came from a high vantage point. Turning the face toward the light source fully washed the face with light, filling in both eye sockets. Also, the arm is positioned away from the body and the weight falls more on one hip, creating curves and angles.

28–70mm lens at 28mm, f/2.8 for 1/15 sec., ISO 400, Aperture Priority mode

THE FOUNDATION FOR EVERYTHING you do should be based on the light, whether you're creating it in the studio or using the natural light of the environment you're in. This is where Bambi first starts to envision the elements of the final image. She looks for an area with a neutral background and with light coming from a clear direction. Using a neutral location allows her to introduce whatever props she wants at will.

This is the time to adjust white balance using the ExpoDisc. It's also a time when Bambi will look through the lens a few times to see how the scene looks on "film." The next and last step is to decide which lens to use based on the area she's going to cover. This decision is based primarily on how much of the scene Bambi's going to show and how many people are going to be in the image.

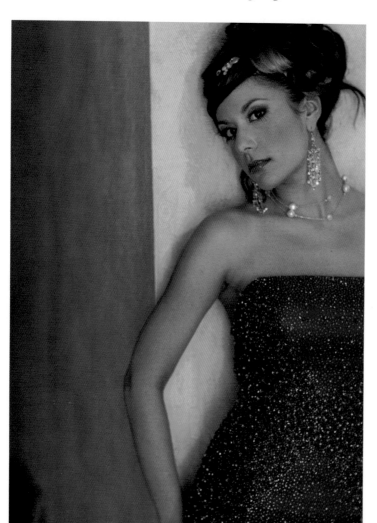

It's a never-ending battle to create images that look different from those of your competitors. If you're looking for some interesting props to add texture and more dimension to your images, hit a junk or salvage yard on your way home tonight. Look for doors, windows, screens, benches—portable products with lots of texture to add to your images.

lighting tip

Strong directional light from a high position is very flattering for a heavier subject.

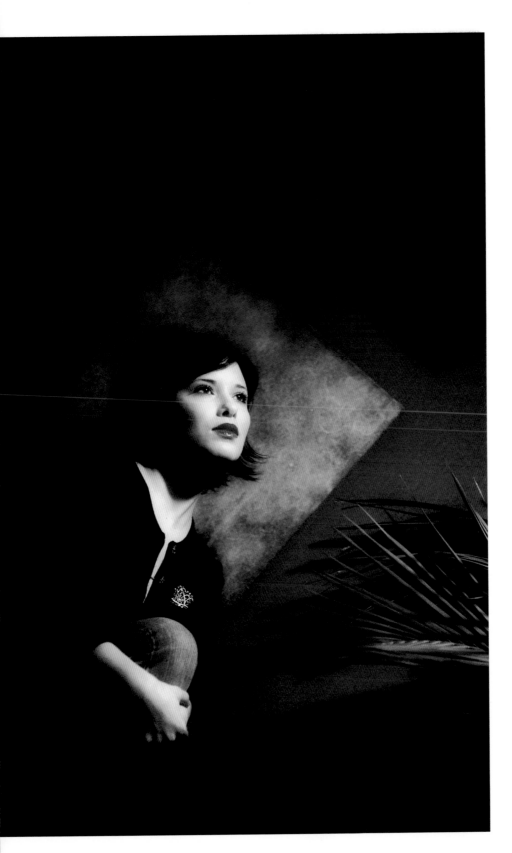

One single light source creates an image with drama. Here, all the light is from one high, recessed light fixture in the ceiling of a hotel lobby. Two things are important here: (1) the subject is looking up toward the light so that the entire face is washed with the light from the ceiling, and (2) shallow depth of field and interesting backgrounds are used. The geometric wallpaper of the hotel is another creative ingredient in this shot.

Also note that the use of a Nik Midnight digital filter increased the saturation, bringing out more red and more contrast in the image, but with a softer edge.

28–70mm lens at 35mm, f/2.8 for 1/10 sec., ISO 400, Aperture Priority mode

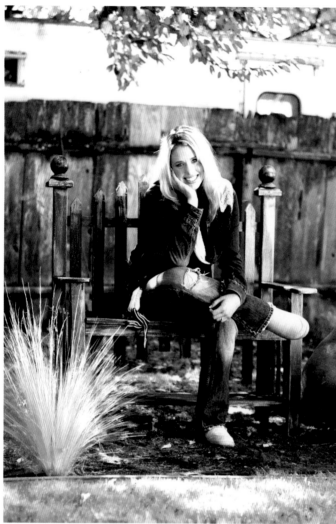

ABOVE: You don't need a fancy studio. Bambi created both this photo and the one at right in her own backyard.

28–70mm lens at 35mm, *f*/2.8 for 1/25 sec., ISO 100, Aperture Priority mode, Nik Color Infrared

RIGHT: This image shows the use of natural backlight (from the sun hitting the back of the subject) to create the hair light (the main light on the side of the head that adds more dimension to the photograph). Bambi also popped the light back into the subject's face on the right-hand side using a handheld reflector. Note that the light is on the side of her face to avoid flat-lighting the subject. This image was created to look like there were three light sources: The main light is on the right-hand side where a single reflector bounces in the sunlight. The backlight is created by the direct sunlight. The light from the natural environment illuminates the rest of the face.

70–200mm lens at 140mm, *f*/2.8 for 1/125 sec., ISO 100, Aperture Priority mode

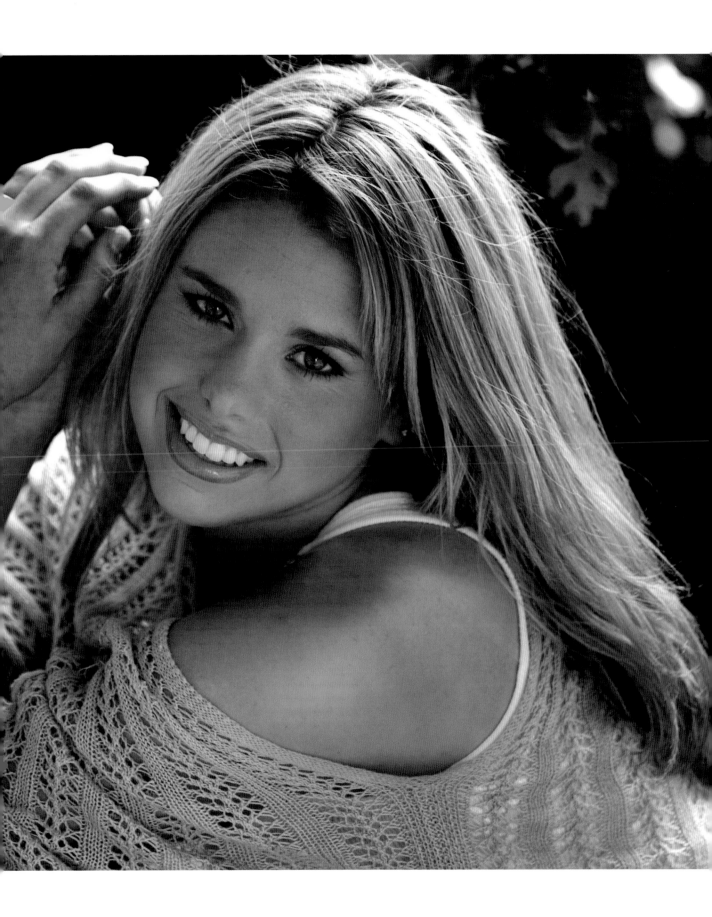

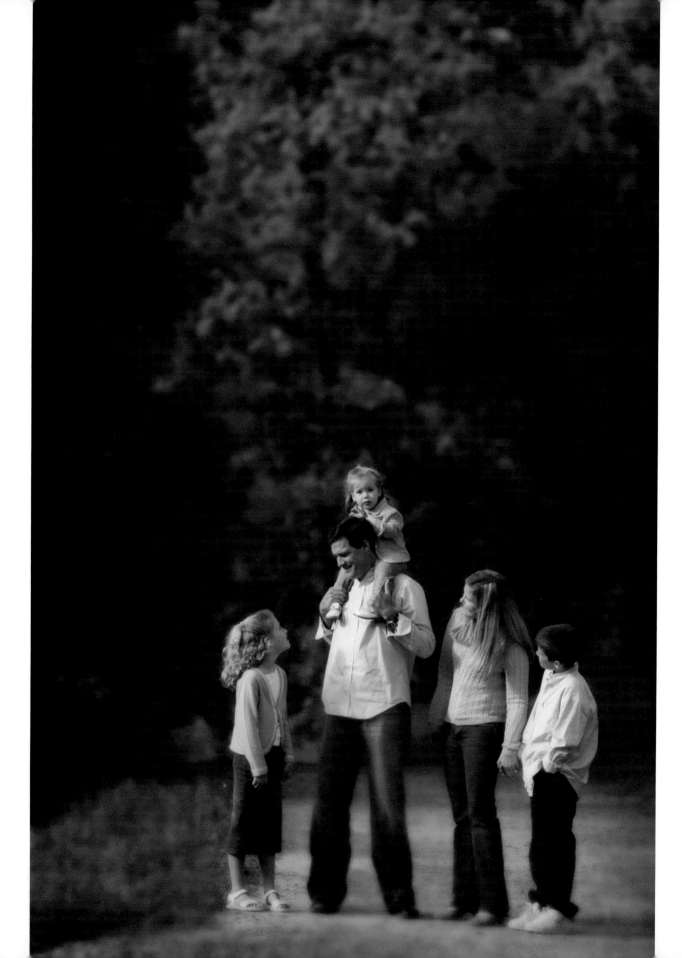

families

The family portrait brings together every variable on the planet and, at times, may well require the alignment of the planets themselves to get a good shot! The variables include location, clothing, individual personalities, pose, lighting, and the mind-set of mom—the person who, more than likely, contracted your services. Great family portraiture is all about creating a single photograph that connects all the members of the family while still capturing the individuality of each person.

things to consider

IF YOU'RE WORKING OUTSIDE, you want a location that gives you an uncomplicated background. You don't need lots of distractions when the story you're trying to tell is of the family. You want soft warm tones and smooth flowing lines in your background, which is why a natural landscape is preferable to the New York skyline, for example.

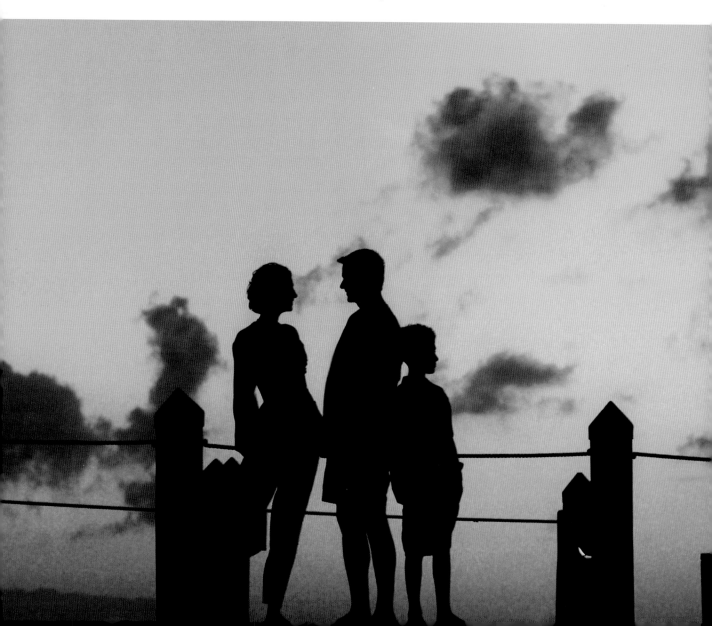

Then, consider the characteristics of your subjects. For example, are they active? Are there young children involved? How long will you have to create the image? You'll need to direct your subjects as to what to wear. You'll want clothing that's monochromatic and uncomplicated. That means no bulky sweaters, and leave out the broad stripes.

The time of day is very critical. Obviously, early or later in the day gives you "sweet light"—those moments in the day when the natural light is softest and warmest—to work with, while photographing in the middle of the day is going to create harsh lighting that you'll need to creatively tone down in the computer.

The pose also is critical, because each family member needs to be positioned in a way that's flattering and that's in keeping with the background. How you pose the subjects will either compliment them or create a horror show. There's a big difference between a pleasing pose and flat-footed, execution-style portraits that prove only that you and the subject were at the same location at the same time.

A great family portrait is about crossing the line into fine art. Your goal is to "become habit-forming": Year after year, anniversary after anniversary, be the first photographer called when someone is thinking of a special gift, a family portrait.

A great family portrait crosses the line into fine art.

Sometimes, a silhouette will create the most impact and give you a totally different look from your other images. Expose for the background. Turn your camera toward the brightest light and simply expose for that, not your subject. Focus on the subject, but meter on the light. The technique adds a more dramatic mood and creates an image that looks more thoughtful.

70–200mm lens at 200mm, f/2.8 for 1/8 sec., ISO 400, Aperture Priority mode

posing basics

POSITION YOUR SUBJECTS so that they create pyramid shapes or triangles. Put people in small clusters. Stay away from the firing-squad approach (everyone standing straight in a row). And, don't be afraid to leave a little space between your subjects.

If any of the subjects are to be seated, the art of communication is critical; you're not just a photographer any longer, you've graduated to director. You want to make sure your subjects don't sit flat on their backside. Instead, have them turn or shift so that they sit on their bottom thigh (more on their side than on their bottom) and have them lean forward, toward you, so that the majority of their weight is behind them.

If your subjects are standing, have them turn approximately 45 degrees away from the camera, separate their feet, and push their front hip away from you while turning the front foot toward the camera.

Remember, you can always break the rules, providing you understand them up front. For example, there may be times when you're going to set up a "group hug" and create the infamous bunch-of-grapes pose, perfect for a message that screams "We love you, Grandma!"

28–70mm lens at 28mm, f/2.8 for 1/15 sec., ISO 100, Aperture Priority mode

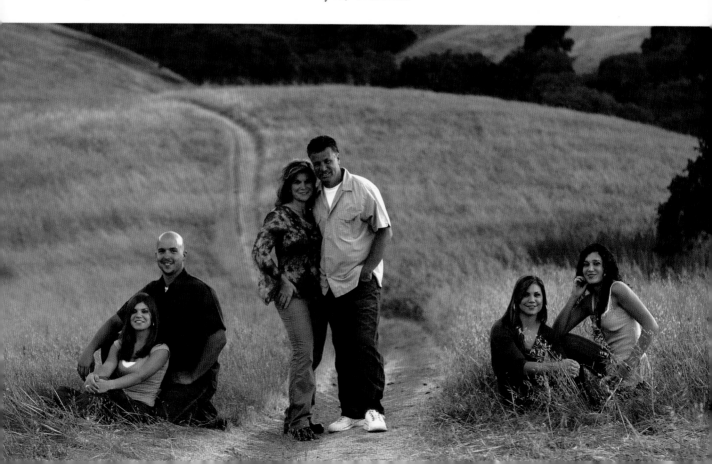

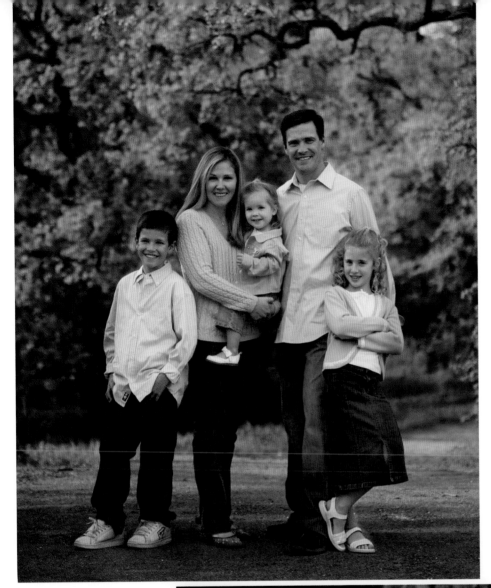

ABOVE: 70–200mm lens at
150mm, f/2.8 for 1/60 sec.,
ISO 100, Aperture Priority mode

RIGHT: 70–200mm lens at
200mm, f/2.8 for 1/60 sec.,
ISO 100, Aperture Priority mode,
Nik Midnight

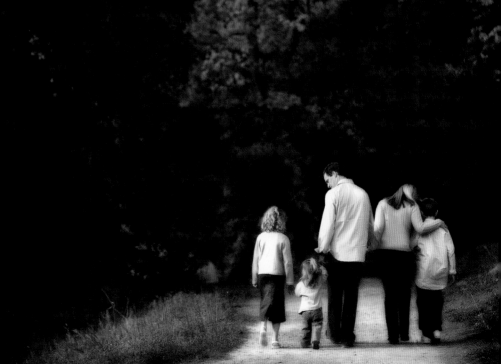

breaking out family details

Photographing one family when there are just two generations present is the ideal opportunity to pair off members of different generations together, capturing additional images of specific family members: dad and the kids, mom and the kids, father and son, mother and daughter, and so on. You could also break out a detail of just mom and dad, too.

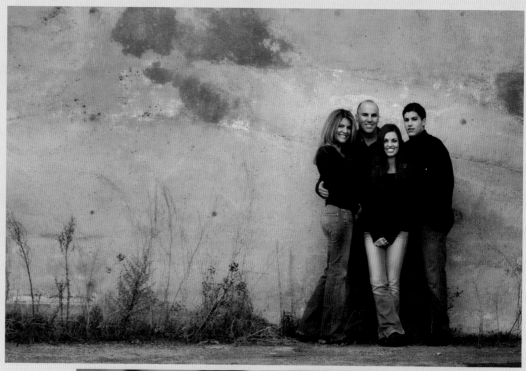

ABOVE: 70–200mm lens at 200mm, f/2.8 for 1/15 sec., ISO 400, Aperture Priority mode, increased contrast by 20%

RIGHT: 70–200mm lens at 200mm, f/2.8 for 1/60 sec., ISO 100, Aperture Priority mode

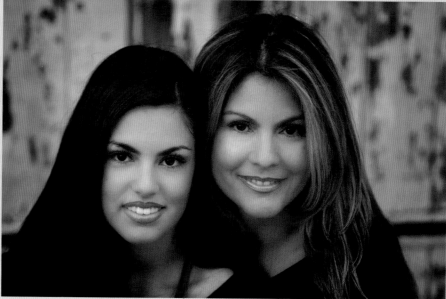

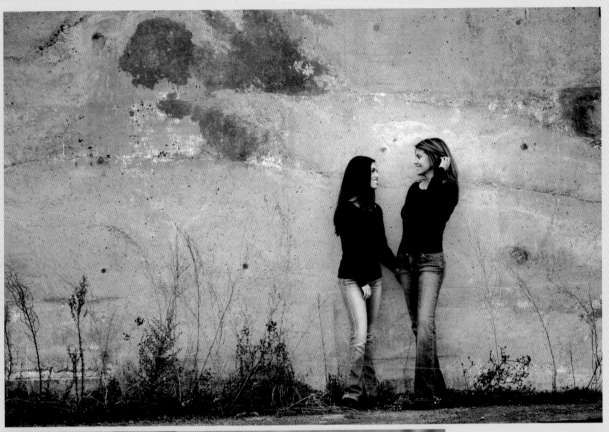

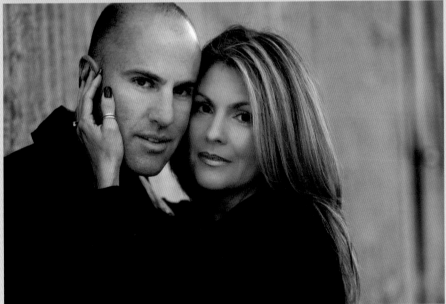

ABOVE: 28–70mm lens at 28mm, f/2.8 for 1/30 sec., ISO 100, Aperture Priority mode, Nik Sepia

LEFT: 70–200mm lens at 200mm, f/2.8 for 1/60 sec., ISO 100, Aperture Priority mode, Photoshop Gaussian Blur

working with several generations

WHEN PHOTOGRAPHING a large group, the toughest group members are the children. Bambi discusses this fact a little in advance of the session with the parents. She wants to work to keep the children's attention—although sometimes it's the parents who keep moving and turning their heads to speak to the children.

If the session involves several generations, Bambi will position the grandparents at the center of the group and build out from there. The key to

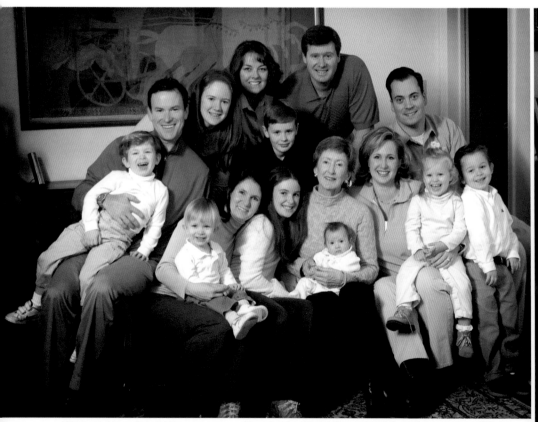

When working with multiple generations, Bambi will work to tell as many "stories" as possible. This will include breaking out the grandparents with grandchildren or even by themselves. She's trying to create as much variety as possible, which, in the end, also creates more choices for the client to purchase. As a suggestion, photograph each family unit, each group of children, each child separately, each adult with his or her parents, the adult children with their parents, and so on.

BOTH PHOTOS: 28–70mm lens at 28mm, 1/60 sec. at f/5.6, ISO 100, Manual mode, main light at f/8 and fill light at f/5.6
Photos © Michael Van Auken

photographing multiple generations successfully is simply to remind the parents to not look at the children and that the kids don't have to be perfect—kids can do no wrong in a family portrait.

When it comes to camera settings, aperture needs to be around $f/5.6$ to $f/8$, giving you plenty of depth of field. Keep the shutter speed high enough to avoid any problems if some of the children do move.

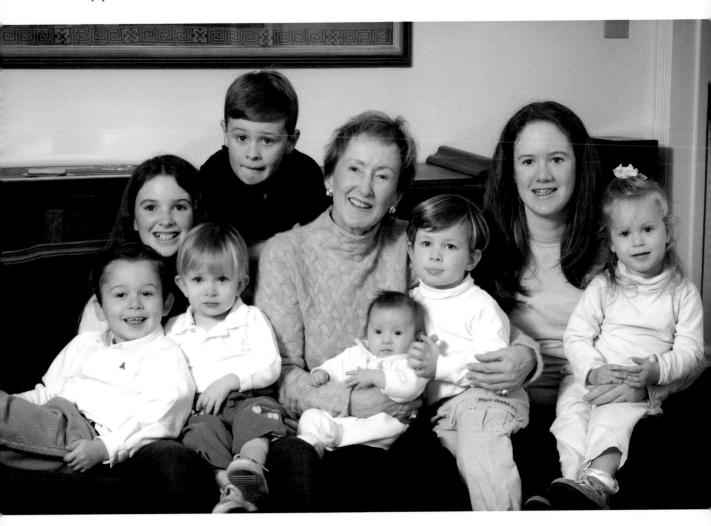

on location

BELOW LEFT: 70–200mm lens at 70mm, f/2.8 for 1/15 sec., ISO 400, Aperture Priority mode, Kevin Kubota Photoshop Action Black and White

BELOW RIGHT: 28–70mm lens at 28mm, f/2.8 for 1/60 sec., ISO 100, Aperture Priority mode, Kevin Kubota Photoshop Action Cross-Processed

BAMBI FAVORS working on location over family portraiture in the studio, but you've got be able to do both. While it's true that you have more control in the studio, you also lose the spontaneity, which is Bambi's strong suit—being on location, dealing with surprises, creating a fun experience for the family (whether it's children, adults, or brides and grooms makes no difference). If you understand how to create the image and have listened to your client, you can approach an on-location assignment with just as much confidence as a studio session.

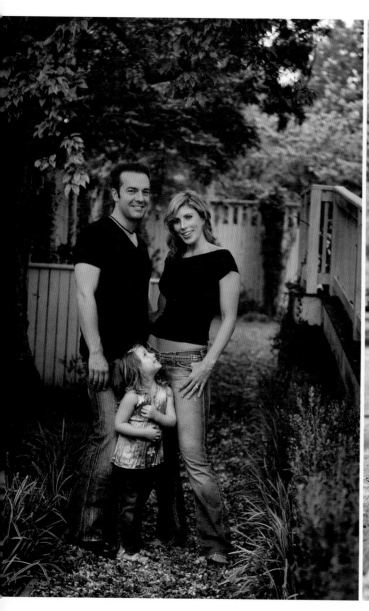
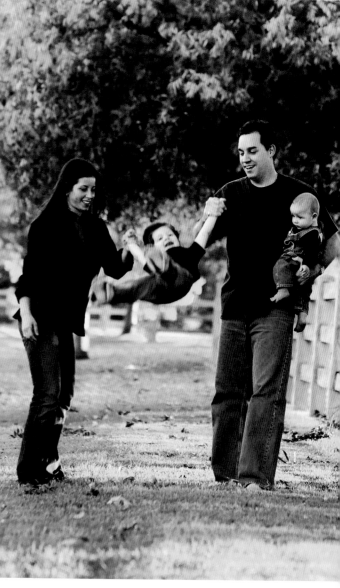

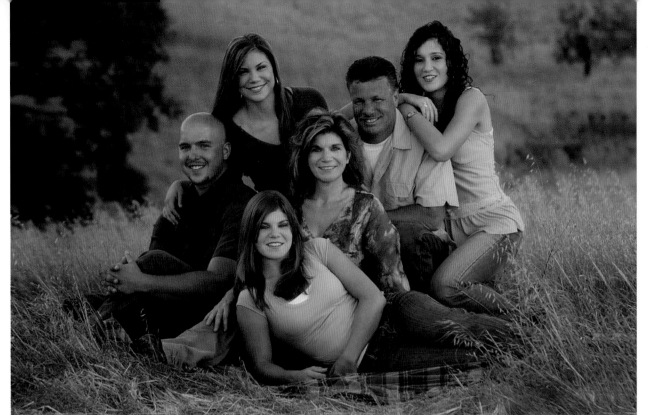

am I on location?

Note that being on location doesn't always mean being outside. It just means you are not working in your studio. You could be in the local park, in a client's backyard, indoors at a client's home, or any other place that's not your studio.

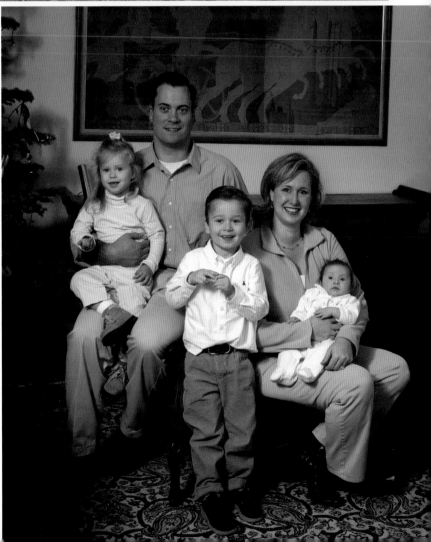

ABOVE: 28–70mm lens at 28mm, f/2.8 for 1/30 sec., ISO 400, Aperture Priority mode
Photo © Michael Van Auken

RIGHT: 28–70mm lens at 28mm, 1/60 sec. at f/5.6, ISO 100, Manual mode, main light at f/8 and fill light at f/5.6
Photo © Michael Van Auken

in the studio

Most photographers will assume, right off the bat, that if clients choose the studio for a family portrait, they're looking for a more formal or traditional look. But it can go either way. This studio portrait of a mother and son looks very contemporary (below). And how about the client who has everyone dress in black (opposite)?

BELOW: 70–200mm lens at 200mm, 1/125 sec. at f/5.6, ISO 100, Manual mode, Proofz Photoshop Action Black and White with grain; OPPOSITE: 28–70mm lens at 28mm, f/8 for 1/125 sec., ISO 100, Aperture Priority mode, Nik Sepia

IN THE STUDIO, all the fundamentals of creating a beautiful image are the same as when you're on location, but now you've got more control. Let's start with the lighting. You're going to use one main light with a large softbox (such as Profoto's 4 × 6–foot softbox). You should also have at your disposal a 1 × 4–foot softbox (again, Profoto makes one).

When it comes to studio props, there are really only two categories: whatever your subjects will sit on and your background. You need a few adjustable posing stools to help you place your subjects at different heights and achieve the triangles mentioned on page 110, and at the same time, a few nice pieces of furniture will help to make the images less sterile and more natural.

The favorite backdrops are those with a classic look. This is all about personal taste, but Bambi tends to shy away from backgrounds that are too contemporary. (It really comes down to loving everything David Maheu has ever made.) She wants a background that enhances the image and doesn't become the focus.

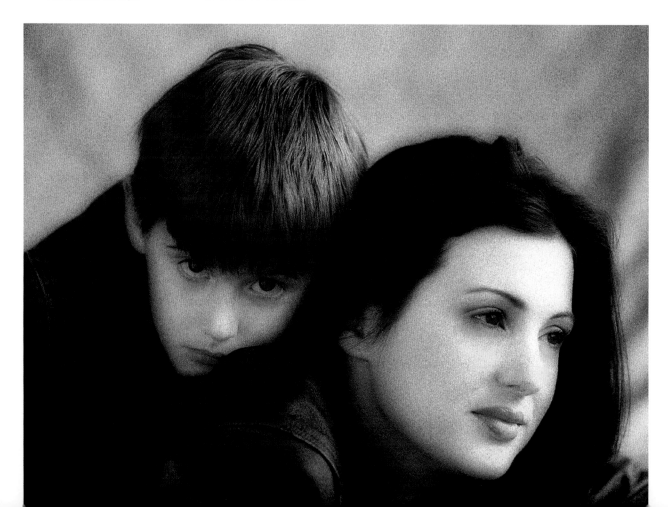

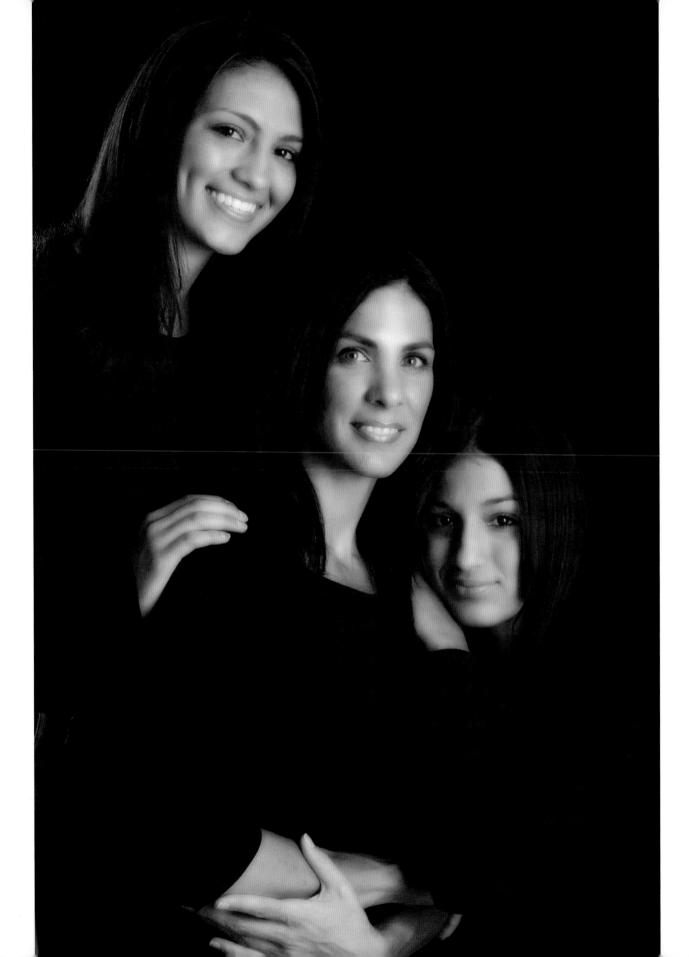

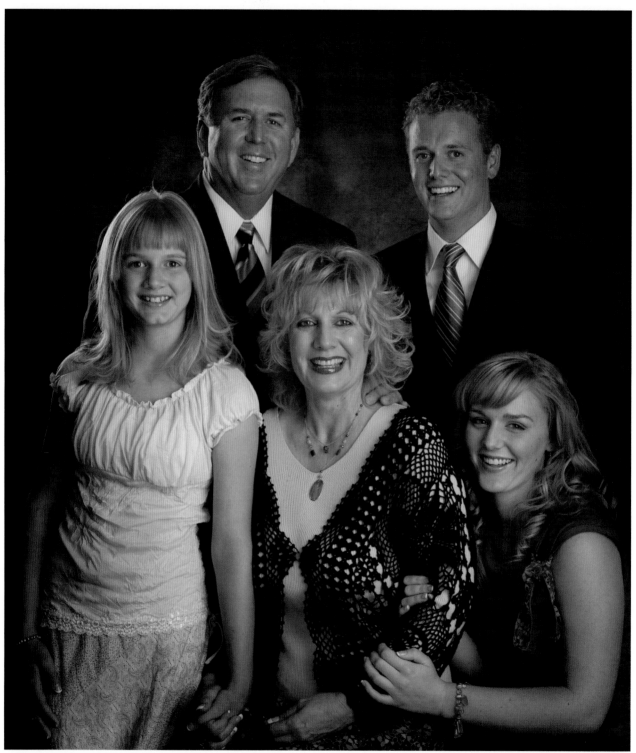

Bambi used Profoto lights to create all the images from this session. Because of this, the color temperature remained consistent in all the color shots, and Bambi was able to get pleasing color right from the start.

ABOVE: 28–70mm lens at 28mm, 1/125 sec. at f/8, ISO 100, Manual mode, main light at f/8 and fill light at f/5.6; OPPOSITE TOP: 28–70mm lens at 58mm, 1/80 sec. at f/6.3, ISO 100, Manual mode; OPPOSITE BOTTOM LEFT: 28–70mm lens at 70mm, 1/125 sec. at f/8, ISO 100, Manual mode, fill light at f/5.6; OPPOSITE BOTTOM CENTER: 28–70mm lens at 70mm, 1/125 sec. at f/8, ISO 100, Manual mode, fill light at f/5.6; OPPOSITE BOTTOM RIGHT: 28–70mm lens at 70mm, 1/125 sec. at f/8, ISO 100, Manual mode, fill light at f/5.6;

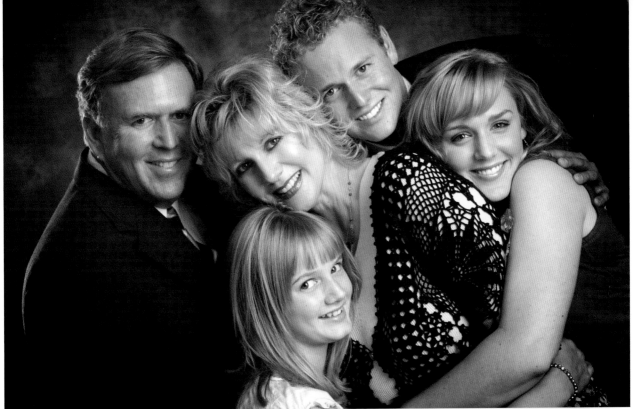

the trend toward elegance

There's a trend today toward elegance both in the casual, on-location portrait and in the more formal in-studio session. In a world in which some consumers think they're Richard Avedon because they just bought the top-of-the-line digital camera, an ability to capture elegance and to create a pleasing family portrait works to the professional photographer's advantage. Uncle Harry can't get the same shots you can, no matter what gear he has in his camera bag!

the kids are all right

WHEN THERE ARE young children in a family portrait, do your best to get the help of an assistant as you work. The challenge here is keeping the kids occupied before you're ready to get the shot. It can be as simple as just playing with the kids and keeping their interest.

Once you're behind the camera, an assistant can help direct the children's attention in whatever direction you want them to look. On location or in the studio, Bambi uses every available toy she can get her hands on, from balls to puppets to squeaky cat toys—anything that's likely to bring a smile and create some fun expressions. And, there's a side benefit: The more you work to make the children laugh, the more absurd you look and the more the adults start to laugh and enjoy your performance, as well.

70–200mm lens at 90mm, f/2.8 for 1/60 sec., ISO 400, Aperture Priority mode

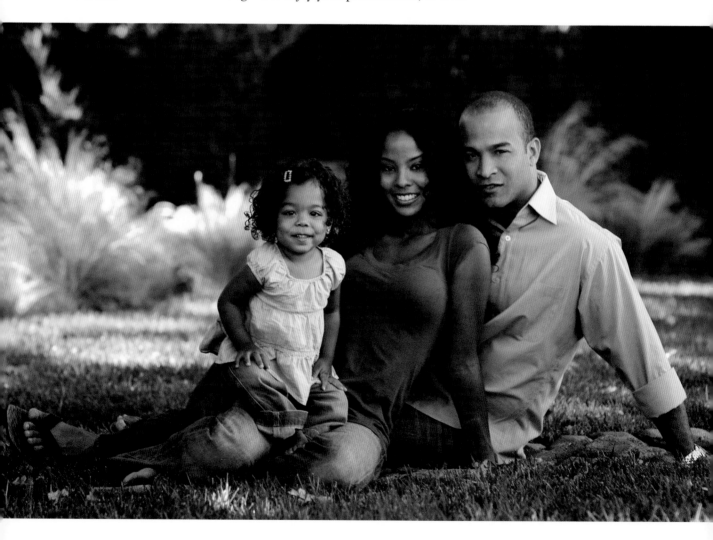

TOP: 70–200mm lens at 200mm, f/2.8 for 1/60 sec., ISO 100, Aperture Priority mode, Kevin Kubota Photoshop Action Black and White

CENTER: 70–200mm lens at 200mm, f/2.8 for 1/60 sec., ISO 100, Aperture Priority mode, Kevin Kubota Photoshop Action Black and White

BOTTOM: 70–200mm lens at 200mm, f/2.8 for 1/60 sec., ISO 100, Aperture Priority mode, Kevin Kubota Photoshop Action Black and White

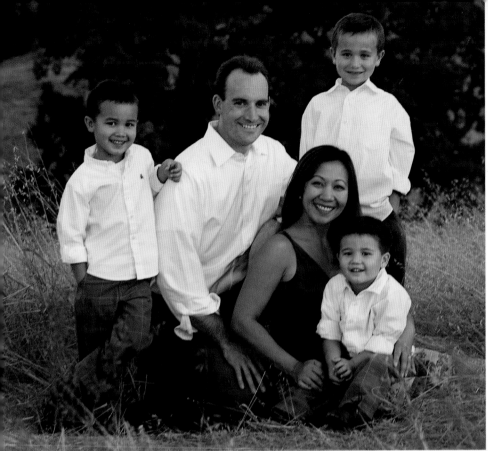

In family portraits, you don't have to make everyone perfect—a sleeve rolled up or a shirt tail out just adds to the fun of the image.

OPPOSITE: 70–200mm lens at 200mm, f/2.8 for 1/60 sec., ISO 100, Aperture Priority mode; LEFT: 28–70mm lens at 50mm, f/2.8 for 1/60 sec., ISO 100, Aperture Priority mode; BELOW LEFT: 70–200mm lens at 200mm, f/2.8 for 1/30 sec., ISO 100, Aperture Priority mode; BELOW RIGHT: 70–200mm lens at 200mm, f/2.8 for 1/60 sec., ISO 100, Aperture Priority mode; BOTTOM: 70–200mm lens at 200mm, f/2.8 for 1/30 sec., ISO 100, Aperture Priority mode

The more you make the kids laugh, the more the adults laugh.

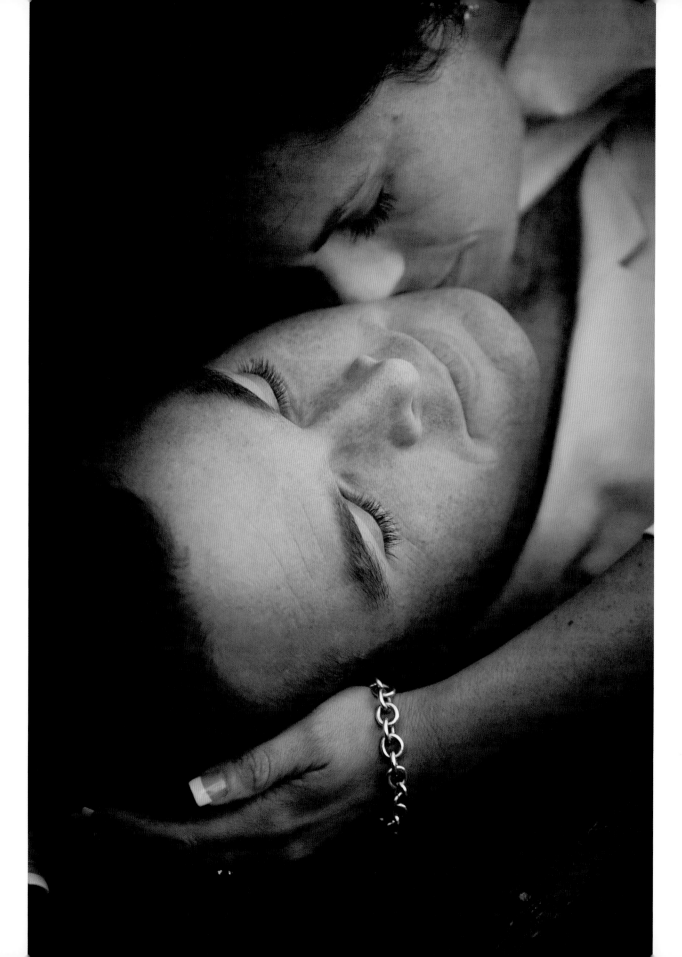

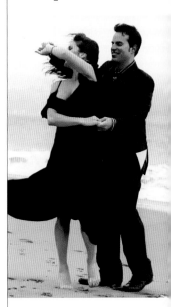

engaged
couples

Photographing couples

for their engagement portrait involves paying attention to the dynamics of the couple. Your goal is to make images that capture the emotion of the couple, suit their personality, and match how they envision their photographs by picking the appropriate environment and creating a relaxed atmosphere.

picking a location

A SUCCESSFUL ENGAGEMENT portrait session starts by listening to your clients. You want to find an environment that's special to them. A studio session is fine, but photographing in a location that's important, and familiar, to the couple will create a more relaxed atmosphere and bring out the interaction between them. You're creating the first images of what will soon become a new family, and it's critical that you take your cues from the people who will make up that family.

You're not just creating a portrait of two people; you're using your ability as a photographer to capture the romance, trust, and perhaps even a little playful apprehension between two people in love. The location is an important tool for helping them relax and express themselves. Bambi likes locations that aren't too busy. She likes a little privacy, giving her and the clients the ability to get to know one another. Remember, she has talked with the clients before the session, asking a few very simple questions in advance, such as, "Do you prefer a more formal or informal location?" This starts the dialogue that helps Bambi determine the kind of environment needed for the session.

LEFT: 70–200mm lens at 2000mm, f/2.8 for 1/60 sec., ISO 100, Aperture Priority mode, Nik Saturation to Brightness

OPPOSITE: 70–200mm lens at 200mm, f/2.8 for 1/60 sec., ISO 100, Aperture Priority mode, Nik Midnight

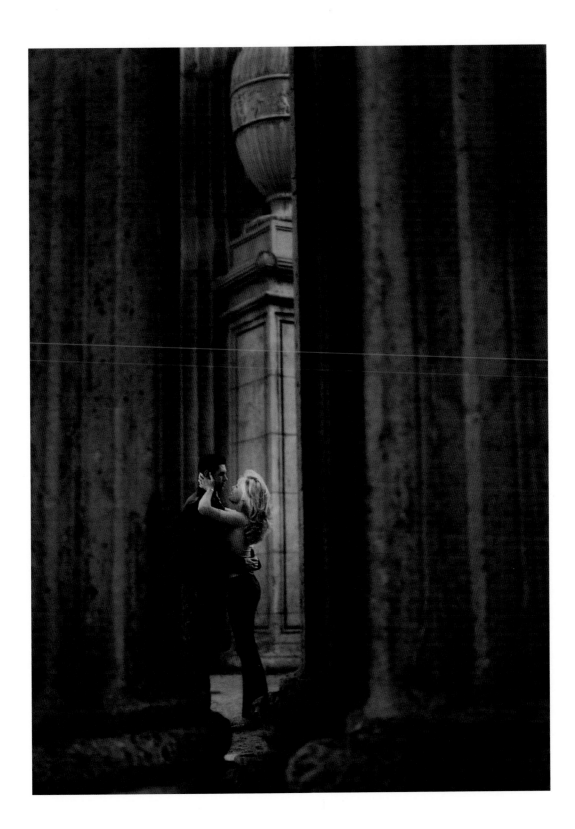

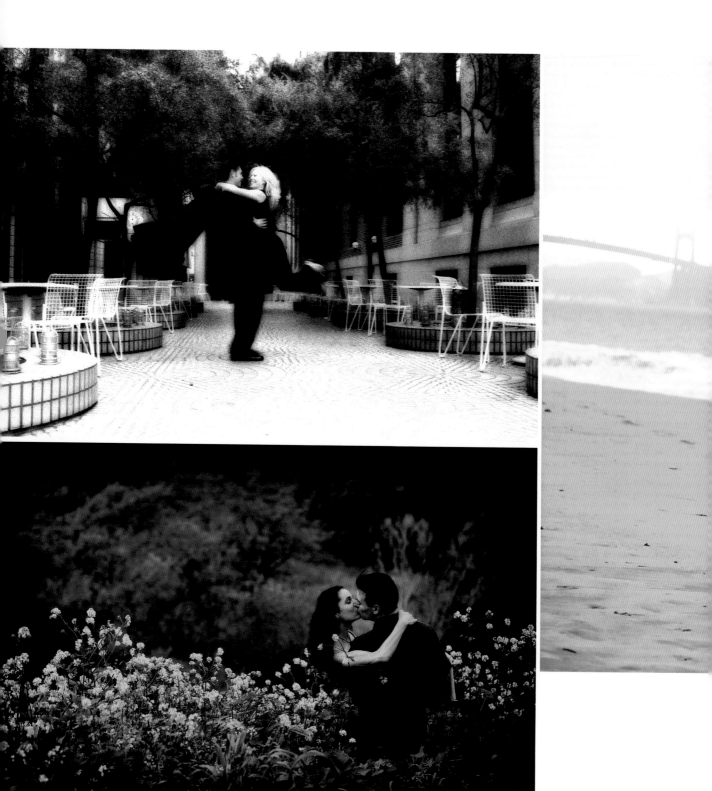

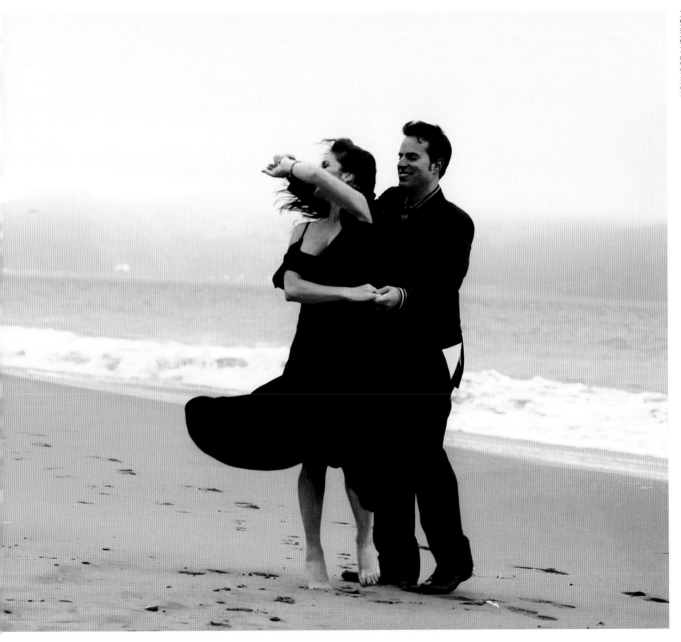

Photographing in a location that's important, and familiar, to the couple will create a more relaxed atmosphere and encourage interaction.

OPPOSITE TOP: 70–200mm lens at 200mm, f/2.8 for 1/30 sec., ISO 100, Aperture Priority mode, Nik Monday Morning

OPPOSITE BOTTOM: 70–200mm lens at 200mm, f/2.8 for 1/15 sec., ISO 100, Aperture Priority mode, Nik Midnight Sepia

ABOVE: 28–70mm lens at 28mm, f/2.8 for 1/30 sec., ISO 100, Aperture Priority mode, Nik Color Infrared

getting started

DON'T MAKE THE MISTAKE of asking the couple too many photographic questions up front. For example, too many photographers err by literally asking, "So what kind of portrait are you interested in?" Most of the time, the couple has no idea whatsoever, because they really haven't thought about it. So instead, be an observer. Ask them if they like to dress up or stay casual. If you've paid attention to how they're dressed, you'll start to get a feel for how casual they're going to be during the actual engagement portrait photo session.

Start the session as a photojournalist, and just let them interact. At this point, you should be shooting with a long lens, and your job is simply to get the conversation going. Ask them questions about how they met, where they're going on their honeymoon, how they met their maid of honor and best man, and so on. As they talk and start to share their stories with you, you'll find it impossible not to start clicking away. And, if they're a little stiff, just have them give each other a big hug. You'll be amazed at the expressions you'll capture without orchestrating a single posed moment.

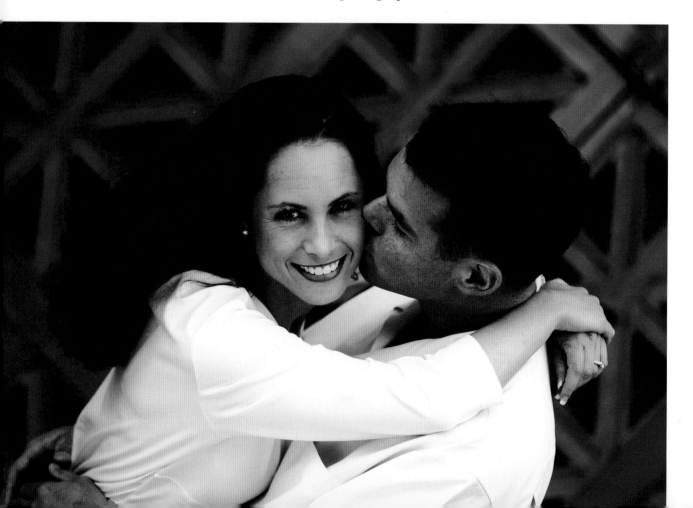

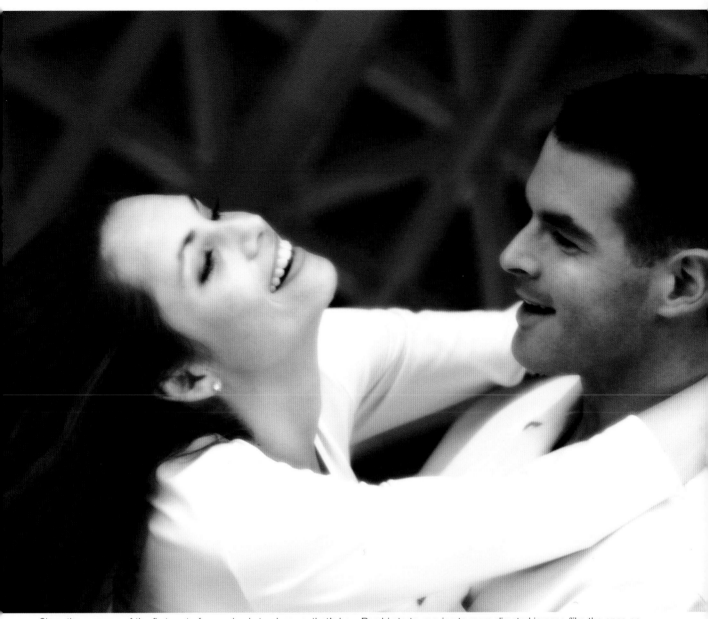

Since the purpose of the first part of a session is to observe, that's how Bambi starts, moving to more directed images (like the ones on the next two pages) later on. Again, your early goal is to get the couple to interact and just capture each moment with the camera.

OPPOSITE: 70–200mm lens at 100mm, f/2.8 for 1/60 sec., ISO 100, Aperture Priority mode, Kevin Kubota Photoshop Action Cross-Processed
ABOVE: 70–200mm lens at 100mm, f/2.8 for 1/60 sec., ISO 100, Aperture Priority mode, Proofz Photoshop Action Infrared #1

long lenses and engagement photography

Throughout the initial part of the photo session, a long lens and shallow depth of field are your best friends. You could be in the middle of a downtown shopping area with a wide aperture and a long lens cranked out to 170mm and still create the most private of images.

Even with a longer lens, the elements of composition are important. Bambi's not just snapping away. Elements in the environment are going to help create high-impact images. You don't want a location that's too busy and distracting. You also want clean natural light with backgrounds that complement the subjects, not fight with them.

As the couple relaxes and starts to get into the groove of the session, you'll find an almost unlimited series of facial expressions. If the eyes are the windows to the soul, then you've got a front-row seat to the hearts of your clients. That long lens in your bag now has a new purpose: to look into your subjects' souls without getting in their faces.

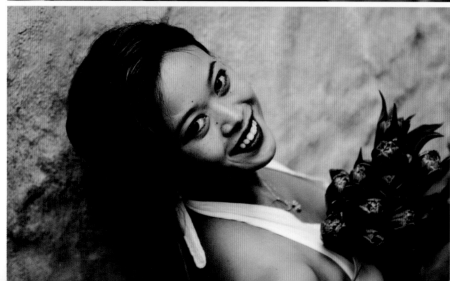

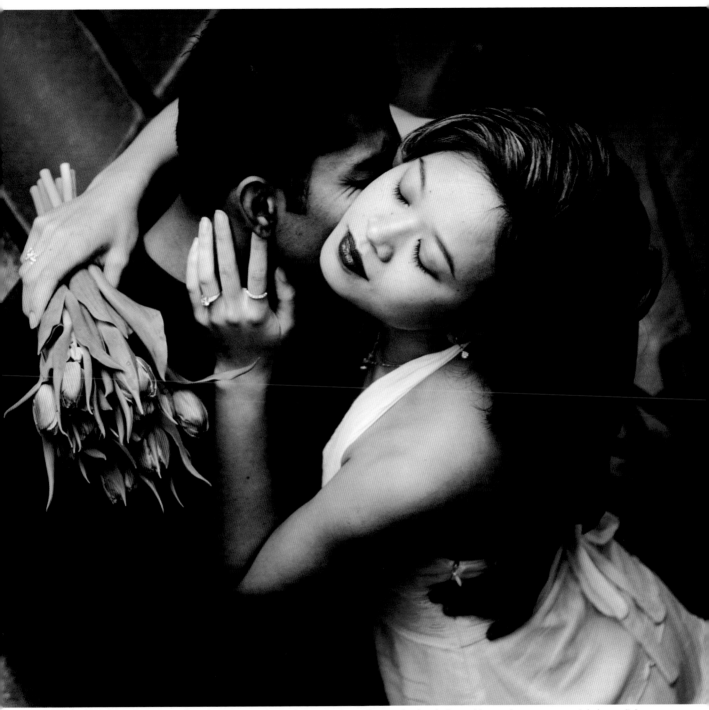

After Bambi has photographed the couple together (above), she continues the session by photographing each person separately (opposite).

ABOVE: 70–200mm lens at 140mm, *f*/2.8 for 1/60 sec., ISO 100, Aperture Priority mode, Kevin Kubota Photoshop Action Cross-Processed
OPPOSITE TOP: 70–200mm lens at 200mm, *f*/2.8 for 1/60 sec., ISO 100, Aperture Priority mode, Kevin Kubota Photoshop Action Cross-Processed
OPPOSITE BOTTOM: 70–200mm lens at 200mm, *f*/2.8 for 1/60 sec., ISO 100, Aperture Priority mode, Kevin Kubota Photoshop Action Cross-Processed

establishing trust

WHEN ASKED HOW LONG an engagement photo session lasts, Bambi's answer is, "I don't even think about it!" You've got keep one thing in mind: This isn't just about creating images; it's about establishing a new relationship with a client. It's not about how many photographs you take, but about your ability to present a quality product and to meet the goals of the bride and groom—and capture them as they perceive themselves.

The benefit to a great engagement session is that over a couple of hours of just fun shooting, you will have managed to get to know your clients. The next time you photograph them will more than likely be their wedding day, and as Bambi likes to say, "It's not a time where logic reigns king!" By developing trust with your clients in an engagement portrait session, you've just made your job significantly easier on the day of the wedding itself. That session will have given you the ability to educate your clients on how you're going to work on the wedding day. You will have developed a familiar pattern of communication amongst yourselves. You will know when the Decisive Moment is because you will have already seen it in their faces. You will have become a friend they can trust, and you will have taken the first step toward establishing clients for life.

The purpose in pulling away isn't just about being an observer; it's about establishing trust with the client. Most grooms come into an engagement session as if they're being forced to pick out wallpaper. If you give the bride- and groom-to-be room to interact and to react to each other, the groom will immediately realize that you're not there to turn him into a trained seal.

28–70mm lens at 70mm, f/2.8 for 1/30 sec., ISO 100, Aperture Priority mode, Nik Midnight

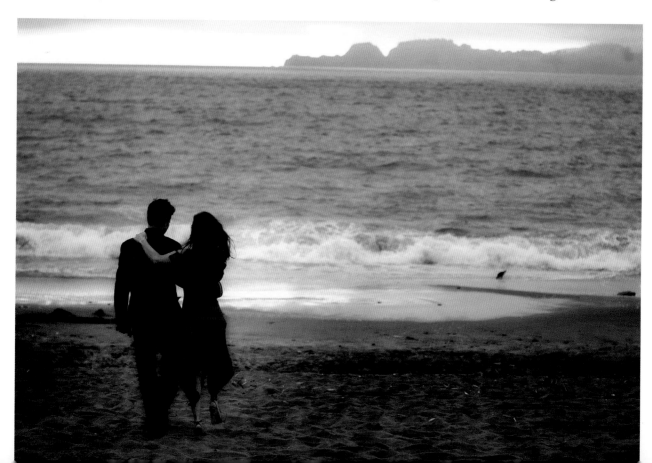

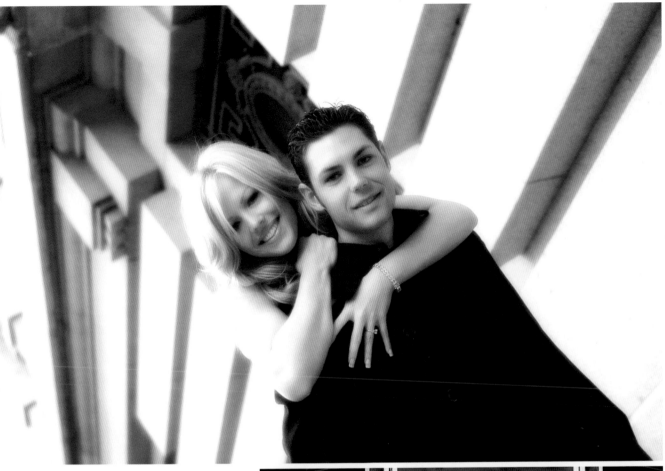

ABOVE: 70–200mm lens at 2000mm, f/2.8 for 1/60 sec., ISO 100, Aperture Priority mode, Proofz Photoshop Action Infrared #1

RIGHT: 70–200mm lens at 100mm, f/2.8 for 1/30 sec., ISO 100, Aperture Priority mode, increased contrast by 45%

breaking things down

The engagement session really has four parts: (1) observation and shooting more from a distance, (2) moving in tighter to capture the emotion in their faces, (3) getting a more introspective look of the couple together, and lastly, (4) "we're just going to play."

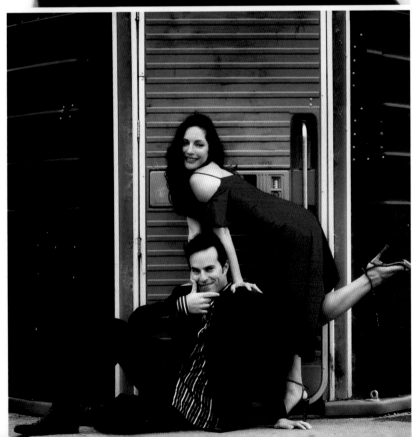

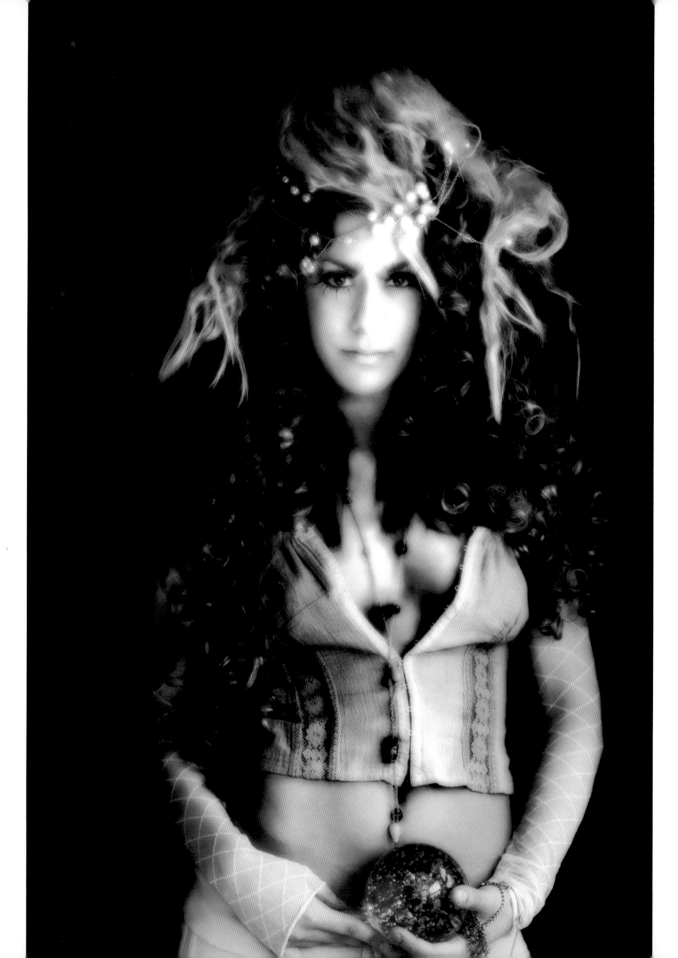

digital enhancements

When digital technology

first appeared on the professional photo scene, a lot of people thought it was the panacea for everything that ailed the working photographer. It was going to save time and money. The reality is that it hasn't done either one, but what it has done is far more valuable. Digital technology has helped make photographers better at their craft. It has given them more tools. It has given them the ability to capture an image, under the most adverse conditions, with instant gratification and feedback. It has given them a paintbrush, along with their cameras. It has become the single greatest influence in imaging since George Eastman. Most important, it is candy for the soul—it's just plain fun!

should you work in color or black-and-white mode?

BLACK AND WHITE is pure. It's about emotion without distraction. In fact, it seems that black and white is more popular today than when it was the only choice. When you choose black and white, even though you have a choice between it and color, that choice makes a statement about the pure passion of an image.

Still, while you can choose to shoot in black-and-white mode in some cameras, we can't come up with a logical reason why you'd do this. Bambi's choice is to shoot in the raw mode *in color* and then convert to black and white in the computer, once she has downloaded the images from the camera.

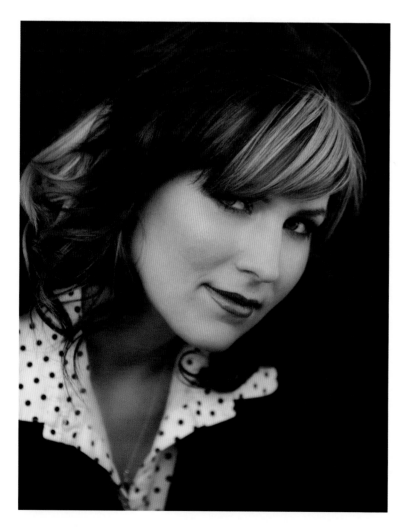

This way, you have the option of keeping the color image, as well as the ability to make a black-and-white version. It's so easy to convert an image from color to black and white in photo-editing software. (Bambi uses a Photoshop action with Kevin Kubota's artistic actions pack; visit www.cantrellportrait.com for more information.) And, as a result, you tend to see the light in the photograph differently.

One of the most fun attributes of converting a color image to black and white is the impact you can add to the photo by pushing the contrast. Here, Bambi used one of her actions to convert to black and white. Then, in Photoshop, she went to Brightness/Contrast under Adjustments in the Image pull-down menu. There, she simply increased the contrast until she liked what she saw. This depends on personal taste as an artist. There's no right or wrong if the image pleases the client.

LEFT: 28–70mm lens at 50mm, f/2.8 for 1/15 sec., ISO 400, Aperture Priority mode; OPPOSITE: Proofz Photoshop Action Black and White, contrast increased by 45%

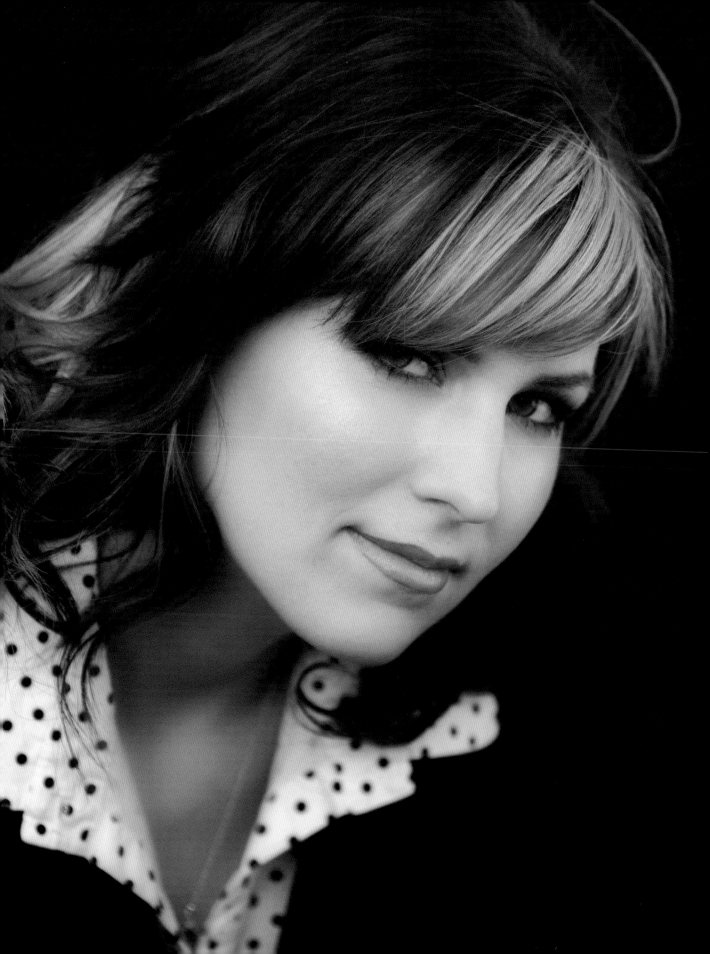

cross processing

CROSS PROCESSING in the film world simply involves shooting transparency film and then having the lab process it in C-41, as if it were print film. The result is a complete shift of the colors, giving images a contemporary, funky look. Remember, the goal is to have fun and create images that not only sell but that let you take full control over the creative process.

In the computer, you can achieve the exact same effect with a digital image by increasing the contrast in a color image by approximately 45 percent. However, why bother to "create your own actions" when Kevin Kubota has already done it for you? It's simply a Kubota action to cross-process an image, and it happens with the simple push of a button. Bambi likes three different actions that she purchased to use with Photoshop: Kevin Kubota's Artistic Tools, Nik Software's Nik Color Efex Pro 2.0, and Proofz from Proofz.com.

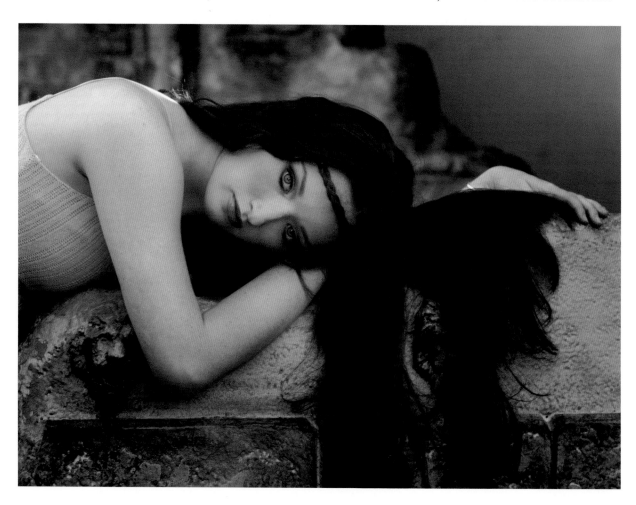

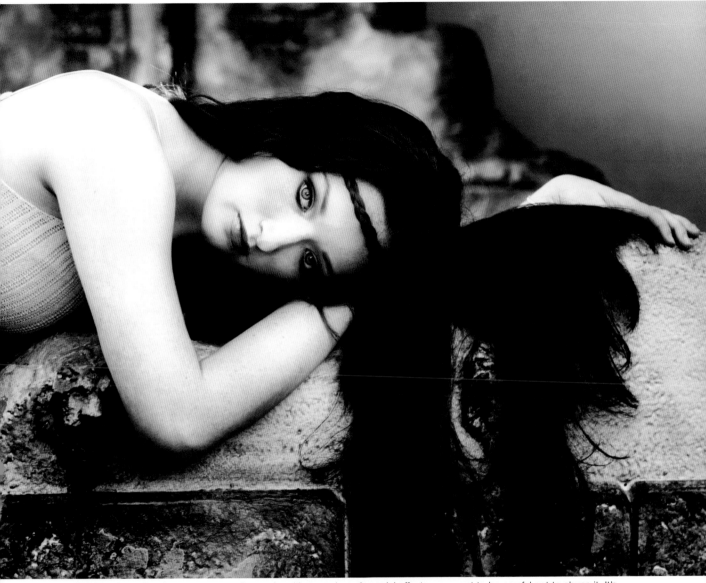

Cross processing is perfect for a younger audience. As with a number of special effects, you want to be careful not to abuse it. It's good for just one or two images in a shoot, and it has to be right for the audience.

OPPOSITE: 70–200mm lens at 90mm, f/2.8 for 1/125 sec., ISO 100, Aperture Priority mode; ABOVE: Kevin Kubota Photoshop Action Cross-Processed

infrared color

INFRARED COLOR (and also infrared black and white on page 146) is another tool at your fingertips to give your images a different look. Whether color or black and white, it gives a portrait a completely different feel. Remember, all of Bambi's original files always start as color images. Adding the look of infrared is, again, a personal choice as an artist. Infrared is like cooking with garlic; you're going to use it sparingly. Only one or two images in an album might be infrared, and typically, the effect appeals is to a younger audience/subject.

Notice the way Nik's Color Infrared software brings out the highlights in the subject's facial features and eyes. The initial image has plenty of impact, but using a plug-in like this gives the image more snap and more of an editorial/fashion feel.

RIGHT: 70–200mm lens at 200mm, f/2.8 for 1/60 sec., ISO 100, Aperture Priority mode; OPPOSITE: Nik Color Infrared

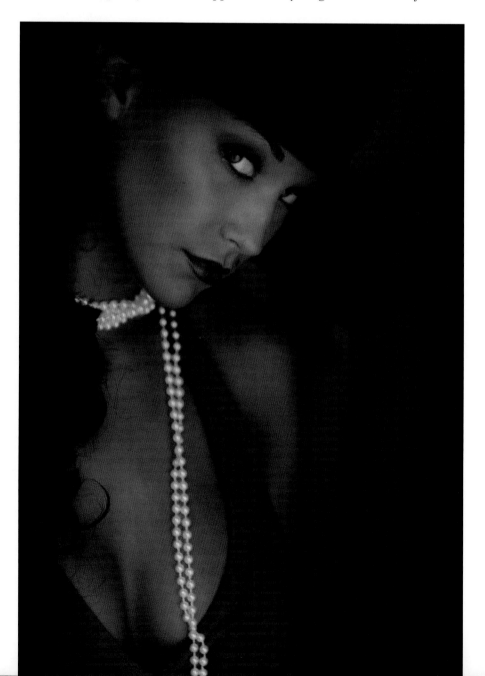

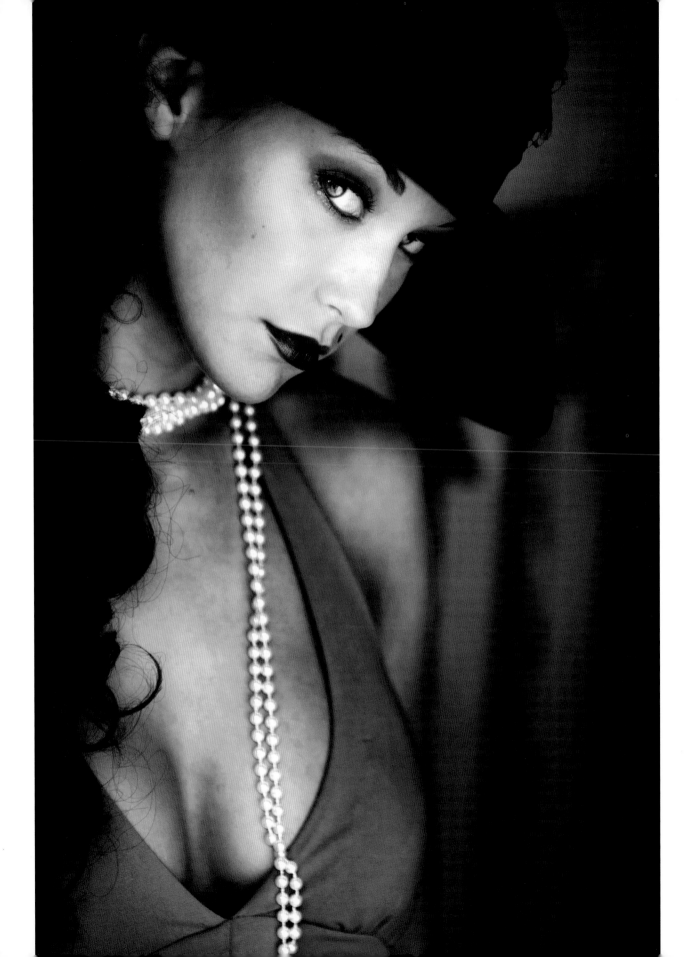

infrared black and white

Thanks to technology, you can achieve the same effect as black-and-white infrared film with software.

ONCE BAMBI HAS CONVERTED an image to black and white, one of her favorite special effects to add is an infrared look. In the "old days" of infrared film, you could only get this effect using actual infrared film and certain cameras. When printed, black-and-white infrared film shifted the tonality from what you were used to seeing with regular black-and-white film. For example, the leaves of a green tree would appear white, almost as if they were covered in snow.

Thanks to digital technology, you can achieve the same effect with Photoshop, Kevin Kubota's filters, or a Nik Software plug-in. Again, it's all about personal taste—don't be afraid to experiment! Also, don't abuse it if you like it. Your clients' main interest is still having you document their event or capture their portrait. Your use of special effects should be limited to enhancing the images by mixing in a few "wow" prints. Just like cooking with garlic, don't overdo it.

This is a prime example of the use of a black-and-white infrared plug-in. Notice how much more dramatic the end result is than the original image.

RIGHT: 70–200mm lens at 200mm, f/2.8 for 1/60 sec., ISO 100, Aperture Priority mode; OPPOSITE: Kevin Kubota Photoshop Action Black-and-White Infrared

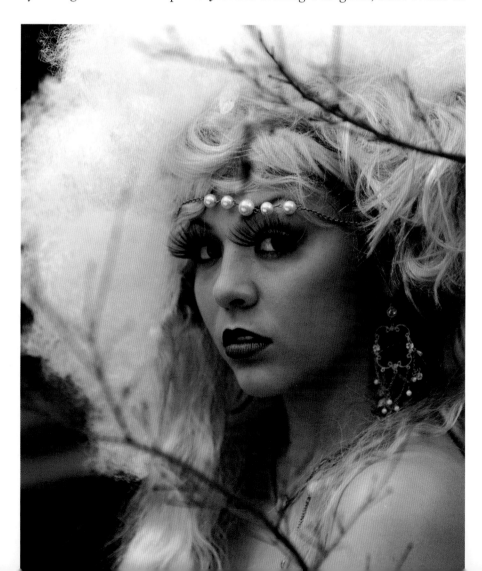

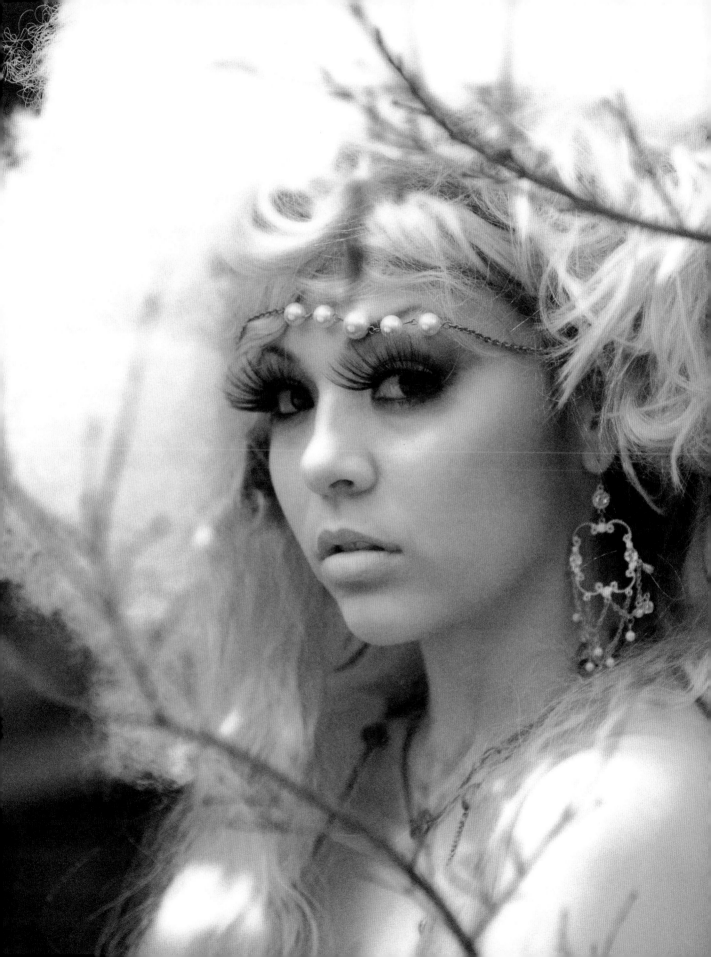

Nik saturation to brightness plug-in

THERE ARE NO RULES on when to use or not use a specific filter or effect. However, for the most part, Bambi tends to reserve these techniques for when she's looking for more of a fashion look and trying to add more impact to an image. One such filter is Nik's Saturation to Brightness. As its name implies, this filter essentially converts an image from RGB into Hue, Saturation, and Brightness, and then swaps the Saturation and Brightness channels. The result is that objects that were highly saturated become bright, and objects that were bright become highly saturated. Using unique processing algorithms, the result is then enhanced to create a more natural and pleasing effect, while providing controls over the final brightness, saturation, as well as the ability to shift the color palette.

plug-ins

Nik and other companies make a full series of Photoshop plug-ins that are ideal for enhancing your abilities and driving your creative spirit to the edge of madness. Plug-ins are additions to software programs. You can buy them, and some are available to download off Web sites for free. They are designed to give you the final result with one easy click.

Photoshop plug-ins are easy to use and simply speed up the process to reach a desired result. For example, instead of spending hours on end trying to find the right combination from an infinite number of ways you could combine and tweak the various Photoshop actions, companies like Nik Software, Kevin Kubota, and Proofz have done the work for you. Plug-ins from these companies are fast, relatively inexpensive, and so much easier to use than if you tried to invent similar processes in photo-editing software yourself.

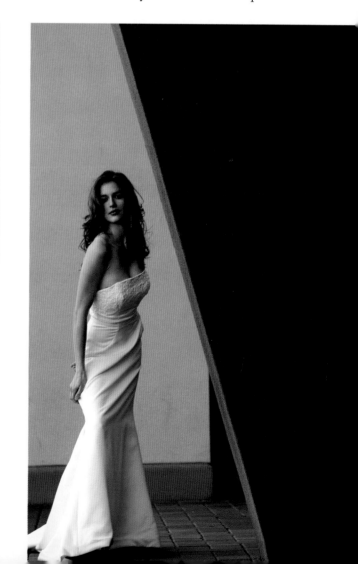

When you start out with dramatic lighting and background colors, the end results can be even better when you use Nik's Saturation to Brightness plug-in. Again, it's personal taste.

RIGHT: 28–70mm lens at 35mm, f/2.8 for 1/125 sec., ISO 100, Aperture Priority mode; OPPOSITE: Nik Saturation to Brightness

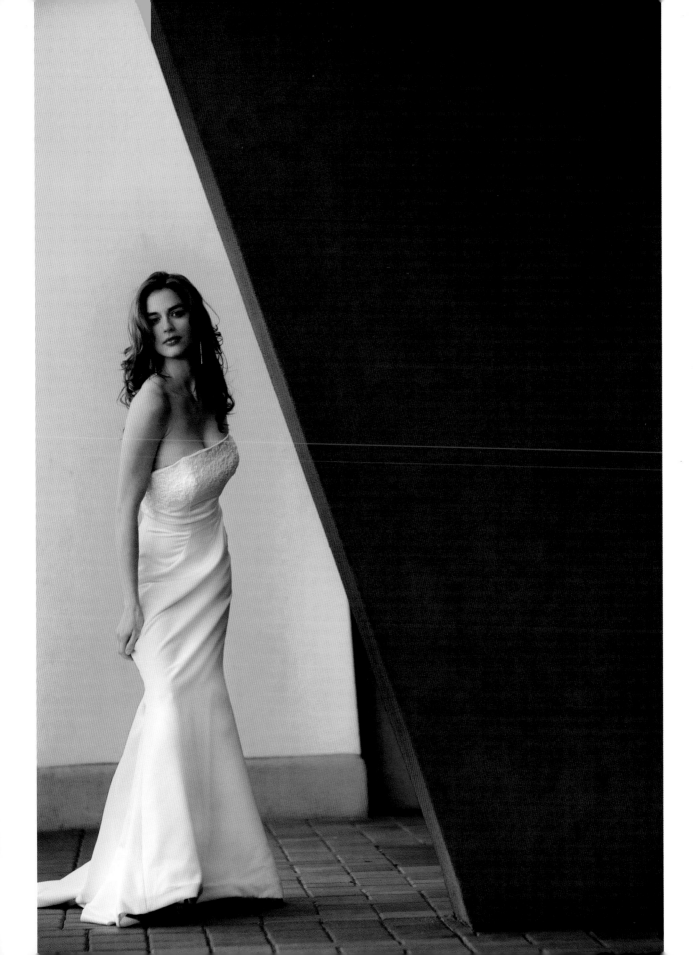

dark strokes

THE DARK STROKES EFFECT is a Photoshop technique that gives an image a more illustrated look. You can make the effect as subtle as you want. As with any Photoshop action, the process starts with the creation of two copy layers of the original image (Control J on a PC or Apple J on a Mac). You then go to the Filter pull-down menu and select Dark Strokes. (With this particular filter, all Bambi used here were the default settings to get the desired effect.) Lastly, click on Flatten Image in the Layer pull-down menu, and save your image.

In the example here, the dark strokes effect resulted in a more handcrafted, painterly look that the client loved.

RIGHT: 28–70mm lens at 50mm, f/2.8 for 1/60 sec., ISO 400, Aperture Priority mode; OPPOSITE: Photoshop Dark Strokes

The fun thing about any digital enhancement is your ability to vary the degree of the effect.

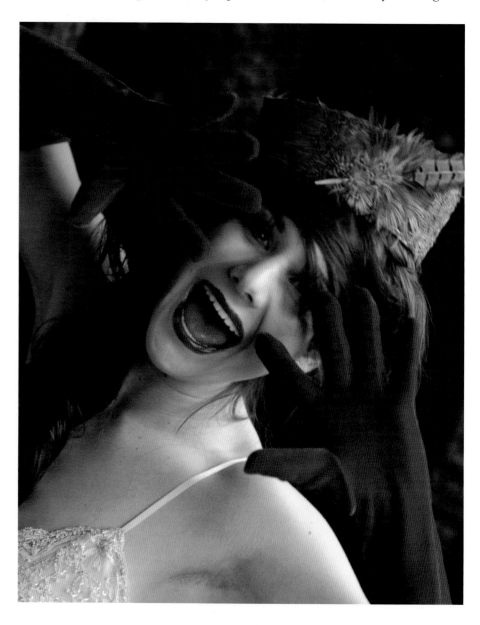

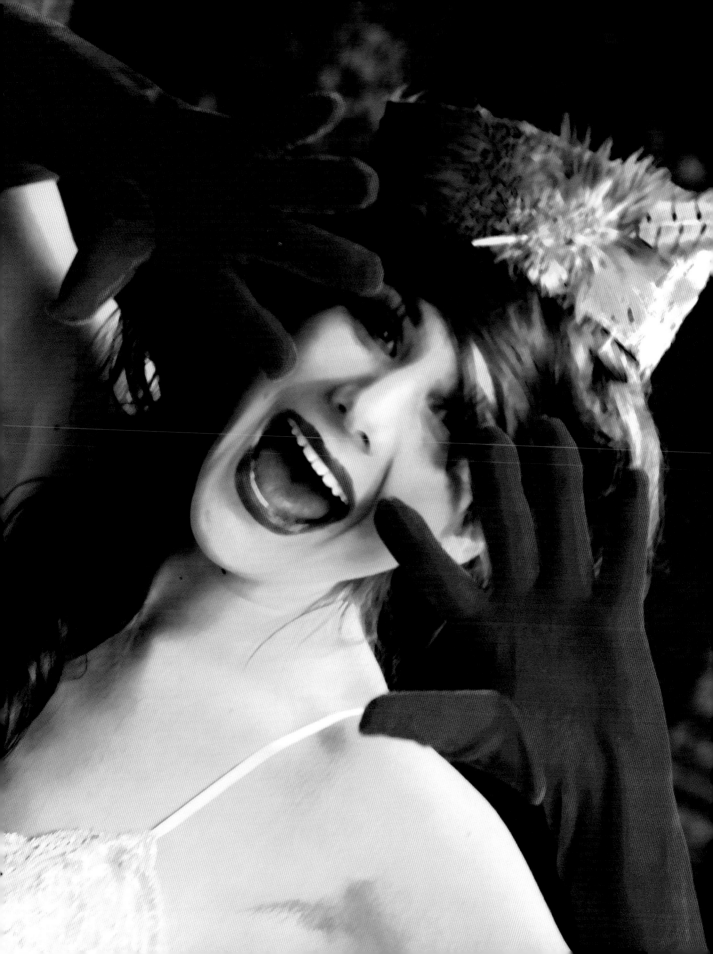

cropping

FOR OVER 90 PERCENT of her images, Bambi chooses to crop in the camera. It saves time, and with digital technology and the LCD screen, you know you got the shot in first place, so why leave yourself additional work later on? Just get it right the first time out, and you won't have to worry about it back in the studio. However, there are some times when cropping an image further in the computer can create a completely new look. The last thing you want is to have people think all your work looks the same.

In addition to creating a new look, cropping can improve composition by editing out distracting or unnecessary elements. Cropping out the yard behind this backdrop resulted in a cleaner, more impactful image.

28–70mm lens at 28mm, f/3.5 for 1/640 sec., ISO 250, Aperture Priority mode

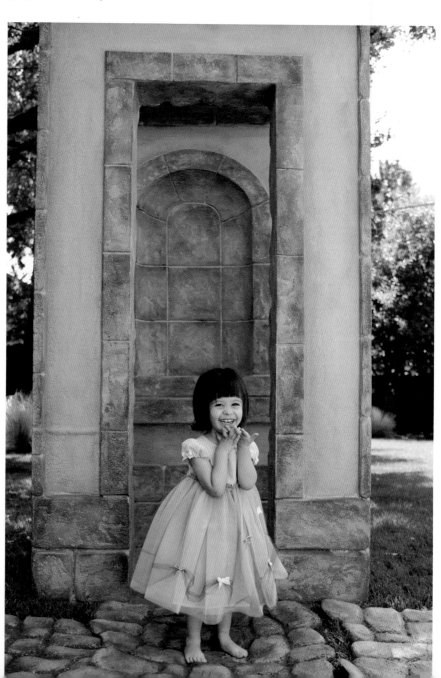

handcoloring

THE TECHNIQUE OF handcoloring an image to impart stylized and strategically located color is an old one, but digital technology let's you re-create this look—and do it sparingly. Traditionally, handcoloring is done by adding color to black-and-white photographic prints with either colored pencils or paints, which are often specifically formulated for that use. Today, you can mimic these effects on digital image files in the computer using photo-editing software. And you don't have to limit it to use only on black-and-white files; you can alter color images to give them a traditional handcolored feel. However, handcoloring, whether done traditionally or digitally, can make a "wow" image cheesy, so be careful.

Bambi captured the original image in color and converted a copy to black and white. She then took the copy and the original and stacked the layers together. Using a Layer Mask in Photoshop, she painted the color back in. To do this, make two copy layers. Go to your Actions palette, and select a black-and-white Photoshop action or plug-in. Bambi used Proofz Black and White Infrared #1 to convert the one layer to black-and-white infrared. Next, go to the Layer pull-down menu and select Add Layer Mask. Make sure the foreground color button in the toolbox is set to black. Using the Brush Tool, set the opacity at whatever you want; Bambi used 30 percent. She moved her brush over the areas where she wanted to paint the color back in. When done, she flattened the layers and saved her work.

RIGHT: 70–200mm lens at 90mm, f/2.8 for 1/60 sec., ISO 100, Aperture Priority mode; OPPOSITE: Proofz Photoshop Action Black and White, Photoshop Diffused Glow

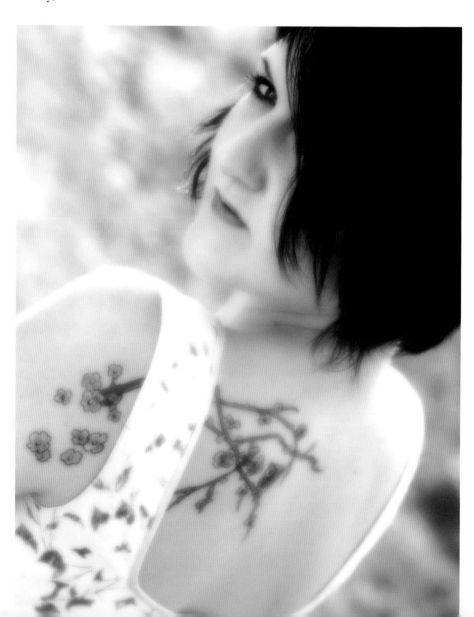

liquify

WHEN PONCE DE LEÓN went looking for the fountain of youth in Florida, little did he know it was hiding in the heads of developers at Adobe five hundred years in the future. Of course, you can deal with Mother Nature's challenges in-camera by using attractive posing, lighting, and so on, but what happens when you've got the image in your computer and need to shed a few pounds off your client? You can use the Liquify filter in Photoshop.

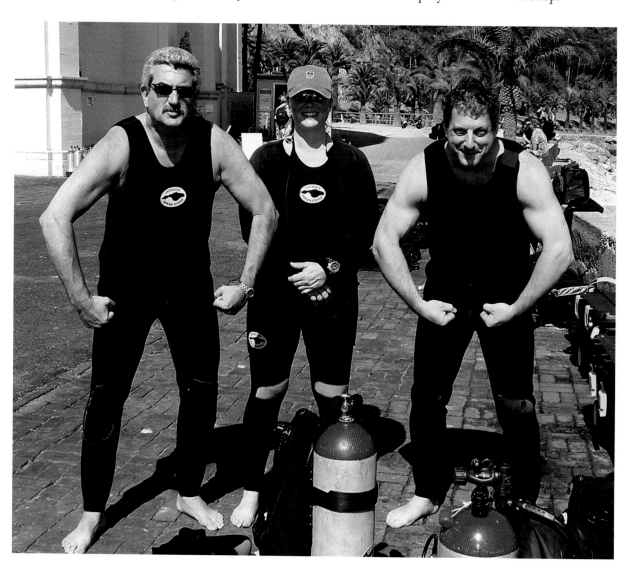

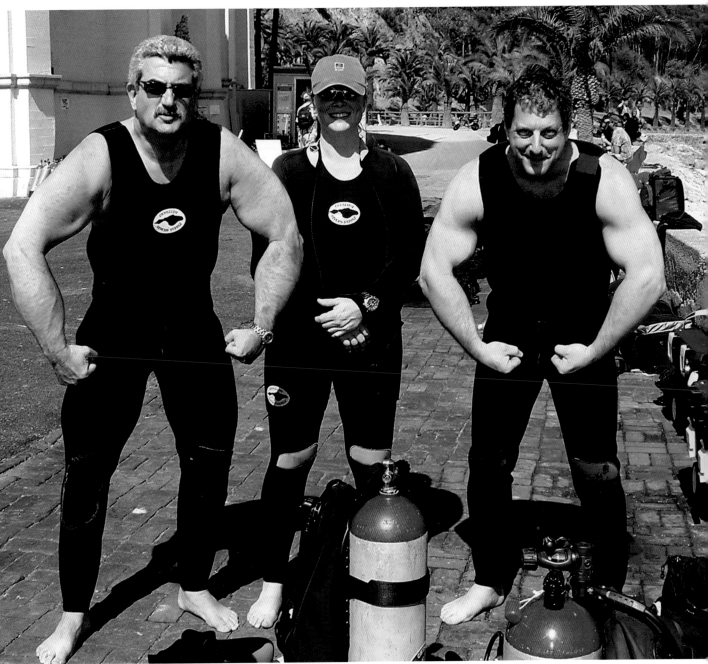

Although you may find yourself using Liquify to trim pounds off subjects, it's more fun to add a few (note the arms here)!

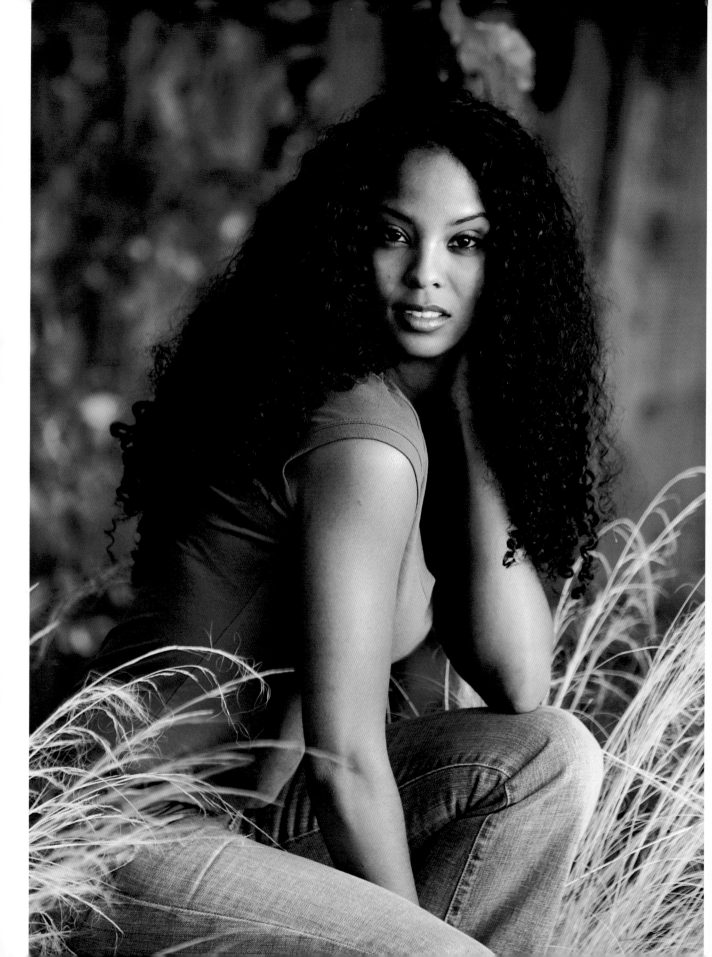

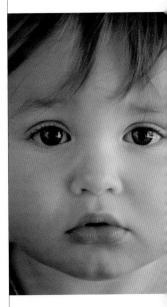

marketing

What good is creating the greatest image of your life if you can't sell it? Unfortunately, the majority of professional photographers spend a lot of time focusing on their subjects but not enough time on a marketing plan. Many photographers are surprised to discover how simple it really is to go through the process. It's just a matter of establishing a few goals and setting a few benchmarks to track how you're doing.

expanding your markets

Children create new photography needs and provide a perfect reason to consider expanding a wedding photography or a portraiture business that may have previously focused only on adults.

BELOW: 28–70mm lens at 50mm, 1/125 sec. at f/8, ISO 100, Manual mode, fill light at f/5.6, Nik Black and White, photo © Michael Van Auken; OPPOSITE: 70–200mm lens at 200mm, f/2.8 for 1/60 sec., ISO 100, Aperture Priority mode, Kevin Kubota Photoshop Action Black and White

LET'S START BY TALKING about expanding from one area of professional photography into another, rather than by simply covering how to build your existing business. I do this because the process is generally the same (you need to expand your database, as you'll see), and this way we cover two scenarios instead of just one. To begin, assume you're a wedding photographer with an interest in diversifying into family and child portraiture. Think about all the brides you've photographed over the last year. For argument's sake, let's say that you photographed twenty weddings over that time period and that your brides (and grooms) loved your work. What are two simple assumptions that you can pretty safely make about those clients that would relate to your new area of photography?

1 The majority of recently wed couples start new families.

AND

2 The majority of those couples have their first child within two or three years of getting married.

From these and any other points you come up with, start thinking about the last time you did any serious marketing. Try tying things together: Odds are, those new brides are now new moms. If your clients loved your wedding work, why not think about targeting all those new moms out there who already know and trust you? Why wouldn't you want to become this new family's photographer for the rest of their lives?

Children create a need for professional portraiture. Children become high school seniors. Seniors become new brides and grooms. Moms and dads become grandparents, and the cycle starts all over again. Meanwhile, all along the way, there are some ideal opportunities for portraits of soon-to-be moms, new babies, families, and businessmen and -women as careers blossom. Sooner or later, you're right back to another bride in the cycle from a new generation.

marketing strategies

LET'S USE BAMBI'S EXPANSION experience as a working example. Again, the concepts detailed here also carry over if you just want to grow your existing business without changing markets at all. Bambi has been photographing thirty weddings per year for the past ten years, and her clients absolutely love her work. The stories of the flowers and thank-you notes she has received are almost legendary. This stable of clients served, and continues to serve, as a database from which Bambi could build her family- and child-portraiture business.

A promotional piece targeted to a specific audience, like this postcard Bambi mails to her recent wedding-photography clients (who might be starting new families), can help get the word out about your expanded services.

r a i t

Specials

equipment & education

Before you focus only on specific marketing strategies, note that the first step when expanding into a new area is to make sure you've got the proper tools, in this case portraiture tools. Bambi had to have the right lighting. She loves Profoto lights. It's all about the quality of light—these are not just lightbulbs! She also had to have the right camera and lens gear for portraiture: in this case, Canon EOS-1D Mark II camera body and 70–200mm F2.8 IS and 24–70mm F2.8 lenses. And, she needed a few accessory items, such as a reflector, a digital meter, some CompactFlash cards, and so on. You know, the basics. (See page 38 for a complete list.)

Then, she needed a printer, as well as a great lab. Bambi is nuts about Epson products and Buckeye Color Lab (www.buckeyecolorlab.com, ph: 800-433-1292). For some applications, she prefers to print her own work and provide the client with instant gratification. Other times (for example, the delivery of an entire wedding album), she needs the support of an outstanding lab. With Buckeye, she gets the quality and consistency she has to have to maintain her reputation as one of the best.

In addition, don't forget about the next element in growing a business: education. You've got to know how to capture the image. There's an interesting quality shared by all of the photographers we consider industry icons: They *never* stop attending other photographers' workshops. They never stop learning. Don Blair was one of the country's leading portrait photographers, and right up to a few months before he passed away at age 79, he was still attending workshops, watching videos of other photographers, and paying attention to the changes in technology. He never developed a been-there-done-that attitude, always feeling that there was more out there to learn. Likewise, Bambi's career started with her attending her first program at Wedding & Portrait Photographers International (WPPI, www.wppionline.com).

identify your target audience

In this case, the target audience was all the brides Bambi had photographed over the last five years. There were 150, and every one of them was a more-than-satisfied client.

draft (and send) very simple personalized letters

In Bambi's example, this letter announced the expansion of her business into the family- and child-portraiture arena.

[date]

Dear Jennifer:

I can't believe it's been two years since I photographed your wedding. I hope you and Troy are doing great.

I'm very excited to share some news about my studio. I've always loved photographing families and children, and have officially expanded my business beyond weddings. In fact, take a look at the enclosed announcement of The Mud Puddle Club.

Hope to see you sometime in the near future.

Best regards,

[space for signature]

B. Cantrell
Cantrell Portrait Design

Sample client letter.

select some "pilot" families

You're looking for a couple of families with the best demographics of your past clients. You want opinion leaders in the community who are going to help spread the word about your services and also allow you to use their images for some of your promotional pieces. Don't underestimate the need to pick attractive families. Like it or not, "pretty" sells.

Every now and then, we've heard photographers say, "I don't have any cute clients." If that's the case, you're part of a community, so start looking around. Are you a member of a church? How about looking around the congregation? Are you a parent in a school system? Without acting like a stalker, check out people at the next parent-teacher night. Still at a loss? How about family friends, relatives, or neighbors? I don't care how much you think the gene pool needs chlorine, everybody can find a family who's photogenic—and photogenic sells!

Larry Peters, one of the country's most outstanding high school seniors photographers, photographs several seniors each year at no charge. These kids become his ambassadors, helping to create more brand awareness for his business. You're going to do the same thing with your pilot families.

A promotional piece aimed at the high school seniors market.

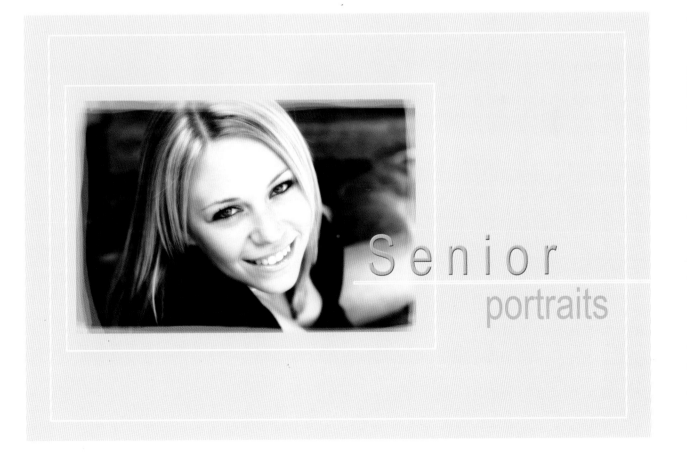

Senior portraits

design a promotional piece

Specifically, design a promotional piece (Bambi also calls this a "sampler") that shows your work within that specialty. In this case, Bambi designed a very targeted 6 × 9–inch card. She took it a step further, making the card an announcement for her Mud Puddle Club, which offers benefits structured like a frequent-flyer program. Club members get four portrait sessions (one every quarter of the year), a free 5 × 7–inch print from each session in a leatherette album, and a deal ensuring that the more they buy, the more they save. It's not rocket science—it just requires paying attention to what your clients need.

A Mud Puddle Club promotional piece.

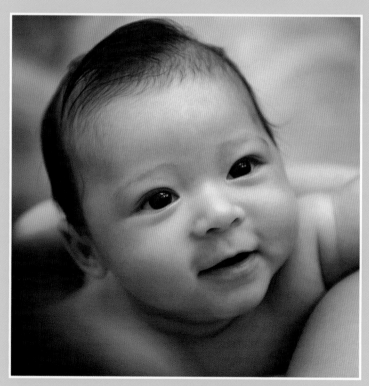
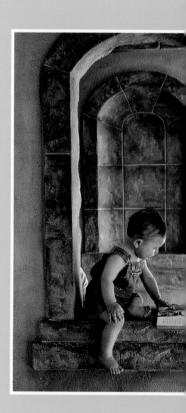

personally sign everything

Think about this one for just a second. How much junk mail do you toss out every day, often not even opening it? Don't waste your money by doing preprinted labels this early in the game. Remember, in our example, Bambi is fighting to get herself known as a child and family photographer, a completely new area for her. A personalized touch can help your materials stand out from the impersonal junk mail most people don't think twice about. So, in each envelope, Bambi includes her personalized letter and the 6 × 9 card of her sample images.

Pay attention to what your clients need.

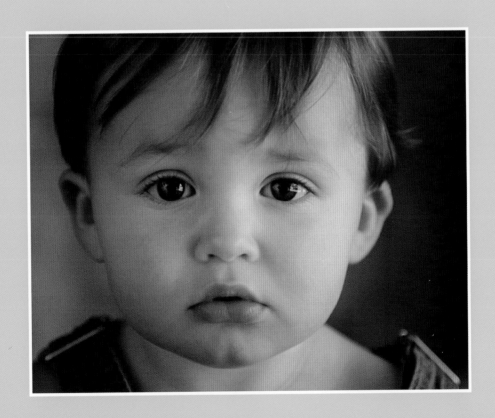

create a press release

At this point, you're ready for a press release. This would include, in Bambi's example, a photograph of Bambi working with one of her "pilot" families. And since Bambi chose a high-profile family to start, she has a better-than-average chance of getting that image published in the local paper.

Don't be afraid to crow a little about your business.

Press Release: Expanded Services

For Immediate Release

Pleasant Hill, California

AREA PHOTOGRAPHER EXPANDS SERVICES
Technology never stands still and neither does the staff at Cantrell Portrait Design. Known primarily as one of the county's leading wedding photographers, Bambi Cantrell is now set up to handle all of the area's child and family portrait photography needs.

"I know most people think of me as a wedding photographer, but we've had so many requests for portrait work, especially kids, we simply wanted to make it official. Whether on location or in the studio, we're now creating some incredibly beautiful portraits," comments Bambi Cantrell. "And, with digital technology changing all the time, we're making sure our clients receive only the very best."

Bambi Cantrell is the founder of Cantrell Portrait Design, located in Pleasant Hill, CA. The studio offers a full range of portrait, wedding, and children's photography services.

For more information, contact Bambi Cantrell at XXX-XXX-XXXX.

[Include image of Bambi photographing a client.]

Sample press release.

twelve press release essentials

When you send out press releases, there are a few essentials. Don't be afraid to crow a little about your business. You've spent a good part of your adult life getting yourself to this point in your career. If you don't let the public know about what you're doing, nobody else will.

1 Let people know what it is you're sending them. Personally, I've always liked the "For Immediate Release" opener.

2 Put a date and a city in the header of the release.

3 Try your best to always come up with a strong headline. (Don't worry, it won't always be possible.)

4 Keep your releases from three to four paragraphs in length—and never more than one page. If there's too much information, nobody will read it!

5 Make the first paragraph the information you want them to know.

6 Personally, I always like a short quote.

7 Always include a closing paragraph that states who and where you are.

8 Include contact information in every press release. This could be your direct contact data or that of a staff member. Believe it or not, some releases—especially ones tied in with charitable causes—will generate a response, often a request for more information.

9 With every press release, include an image of you interacting with another person who is somehow related to the theme of the press release.

10 Be patient. Keep sending releases out whether they get published or not.

11 Be patient.

12 Be patient!

get involved in your community

Just when you thought you were done, and could sit back and watch the cash roll in, we're giving you more work to do! Here's the key to every marketing plan: People like to buy products from companies they perceive as giving something back to the community. In the world of big business, this is called *cause-related marketing*, and nothing can help you build your image faster.

Even if you think you don't have the time, there are opportunities to get involved. Bambi regularly donates portrait sessions to fund-raising auctions at the local schools, children's charities, and a local battered-women's shelter, to name just a few.

Networking just involves a little common sense.

Bambi's marketing plan has to keep her name out there. She has to get involved in activities in the community she's targeting. She has sent out only one press release in the example we're using here, but she knows she needs to keep creating opportunities for more outreach. Put this in perspective for your own business. The community has been good to you; it's simply time to give something back.

network, network, network!

Building your business is about being involved and developing strategic alliances with other noncompeting members of the business community. Bambi has invested a great deal of time in cultivating relationships with florists, event planners, catering managers at her favorite hotels, travel agents, makeup artists, and hairdressers. This is where that fruit basket Bambi dropped off at her favorite florist pays off. This kind of networking just involves a little common sense and relationship-building.

And don't laugh about your relationship with the local hairdresser! Bambi's passion is creating a fashion look in her images. Who better to provide a continuous flow of good-looking models for Bambi's portfolio than her favorite hairdresser? And, like any great hub of community involvement, where's "Gossip Central" in your community? You got it—it's right there at the local hairdresser's!

Taking it one step further, again, who makes 95 percent of the decisions about purchasing professional photography? Anyone who said "dad," please return this book and get your money back! Seriously, it's *mom*. And, where does mom get her hair cut?

The benefits of working with a hair salon are endless. Every six to eight weeks, Bambi's favorite hair salon (Wild Orchids in Antioch, CA) has what she calls Hair Wars. From body paint to hair extensions, nothing is off-limits. Bambi photographs the event, provides free prints to the models and to the hair salon, and uses these sessions to simply experiment with different photographic techniques. She doesn't charge them a cent. How could she? She has way too much fun in the process. Plus, when the smoke clears, all the images are posted on the salon's Web site and displayed on the shop walls. Every stylist there becomes an ambassador for Bambi's work. And, every time they're in the salon seeing Bambi's name on every print, clients pick up that subliminal message. It's a publicist's dream, but it didn't happen overnight. It took time and required that Bambi build a relationship that was a win-win situation for everybody involved.

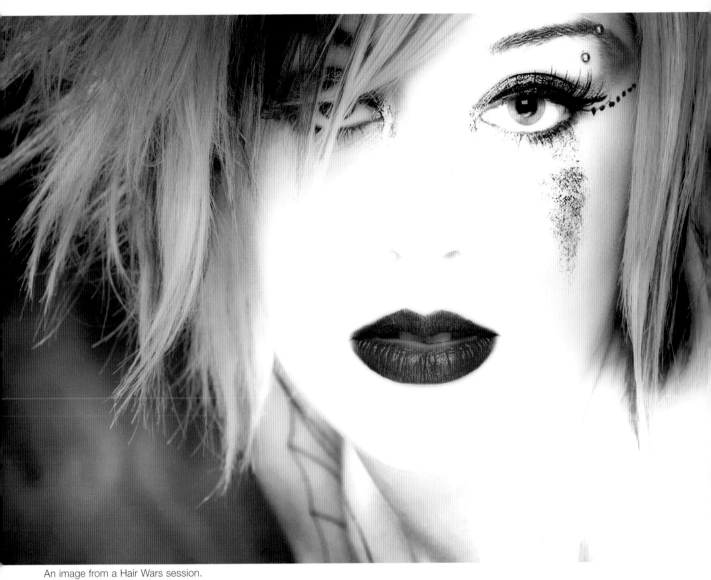

An image from a Hair Wars session.

70–200mm lens at 200mm, 1/124 sec. at f/2.8, ISO 100, Manual mode, fill light at f/5.6, Photoshop Diffused Glow and Nik Color Infrared

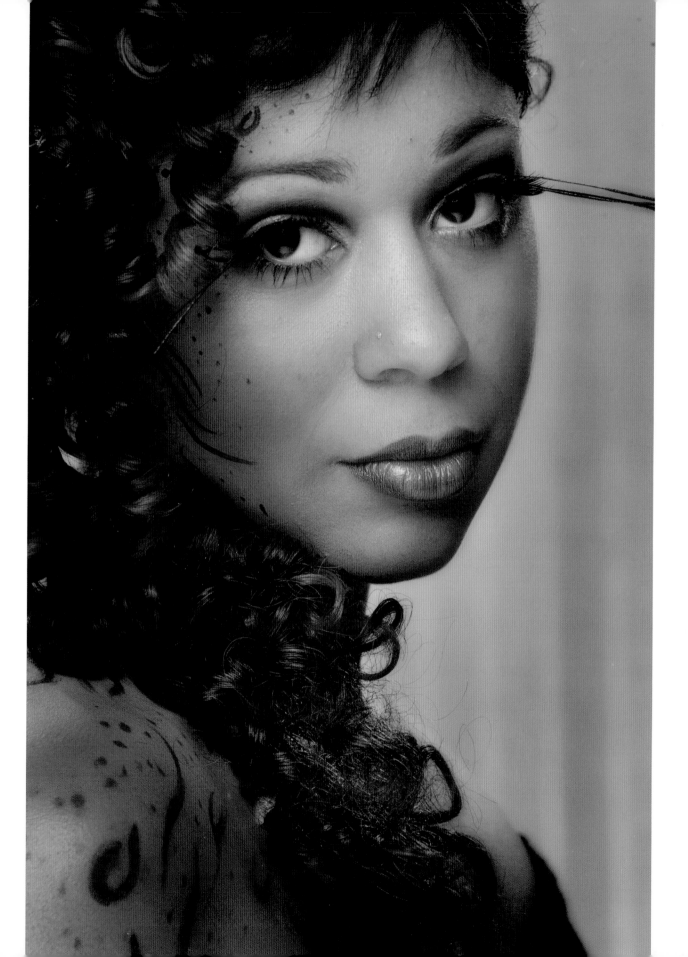

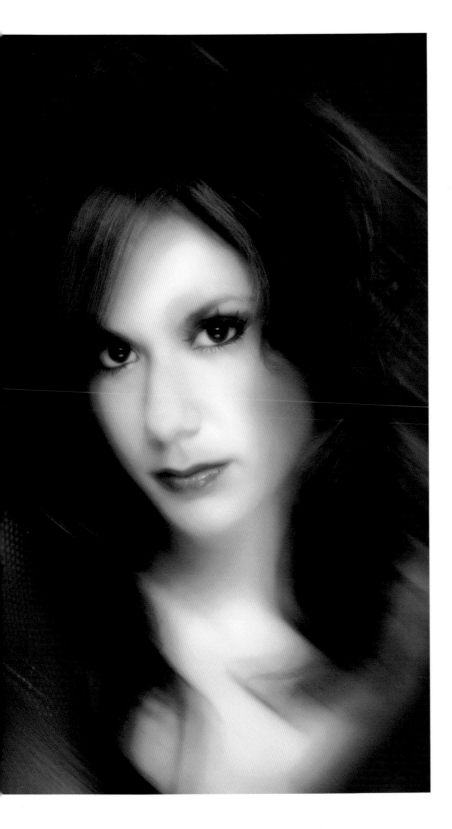

other markets

We've just built a model to take Bambi into the child and family portraiture markets, but let's assume that you're already a children's photographer and that you just want to build your existing business, not start a new one. The process is the same. You need to expand your database, starting with your existing clients. You're going to follow the same business marketing plan, sending a letter to existing customers. Next, you're going to look for ways to expand that database to new clients, through direct mail, advertising, and publicity.

If you're looking for ideas on finding lists of potential clients in a broader market, check out www.listservicedirect.com. It has an extensive database, and you can mine the data by almost any demographic you wish.

Whatever you do, don't ignore the marketing aspects of the job. As we said at the start of this chapter, What good is creating the greatest image of your life if you can't sell it?

It's not just about capturing images during Hair Wars. It's about Bambi having a chance to experiment with different techniques. What a concept—to be able to simply "play" with your camera and computer! It's all about "fun," that word that too often gets lost in business today.

OPPOSITE: 28–70mm lens at 50mm, 1/125 at f/2.8, ISO 100, Manual mode, fill light at f/5.6; LEFT: 28–70mm lens at 50mm, 1/125 sec. at f/2.8, ISO 100, Manual mode, fill light at f/5.6, Photoshop Diffused Glow and Motion Blur

a final thought

If Ethel Merman could belt out "There's No Business like Show Business," then we want to scream at the top of our lungs, "There's no business like photography!" Think about what the world would be like without images. Weddings would be reduced to a series of stick-figure drawings—or distant memories. A portrait would entail sitting long hours for, maybe, a faded charcoal sketch, and the list goes on and on. With the exception of modern medicine, nothing gives the world what photographers provide.

So, we've only one closing point to make: If you're not having the time of your life as a photographer today, then you're doing something wrong. Step back, look at your images, and think about why you chose this career in the first place. What a kick it is!

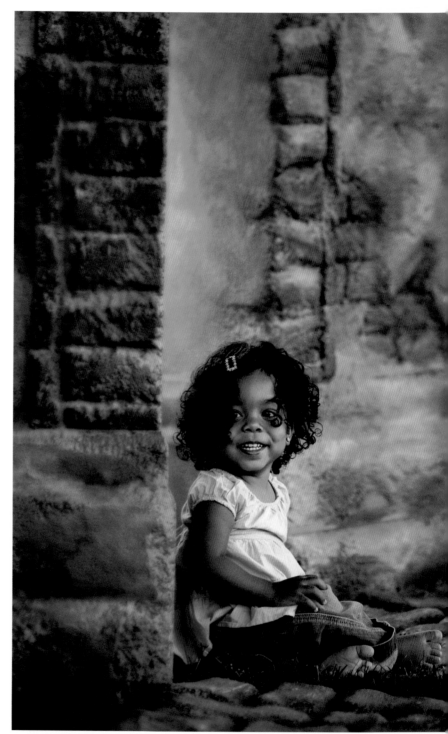

70–200mm lens at 150mm, f/2.8 for 1/160 sec., ISO 100, Aperture Priority mode

index